HIDDEN
HISTORY
of
NEW JERSEY

HIDDEN HISTORY
of
NEW JERSEY

Joseph G. Bilby,
James M. Madden
& Harry Ziegler

THE
History
PRESS

Published by The History Press
Charleston, SC 29403
www.historypress.net

First published 2011
Second printing 2011
Third printing 2012
Fourth printing 2012

Manufactured in the United States

ISBN 978.1.60949.463.6

Bilby, Joseph G.
Hidden history of New Jersey / Joseph G. Bilby, Harry Ziegler and James M. Madden.
p. cm.
ISBN 978-1-60949-463-6
1. New Jersey--History. 2. New Jersey--Biography. I. Ziegler, Harry F. II. Madden, James
M. (James Martin), 1964- III. Title.
F134.6.B48 2011
974.9--dc23
2011042016

CONTENTS

CONTENTS

INTRODUCTION

Hidden History of New Jersey features a series of little-known and/or long-forgotten New Jersey history tales spanning the years from 1755 to 1951. This method of revealing and illuminating aspects of the Garden State's past through brief historical essays is not unique and has its origins with Frank Stockton in 1896. More recently, the motif has been used successfully (and far more accurately than in Stockton's romanticized stories) by noted historian Marc Mappen in his two popular volumes on New Jersey's past. In 2011, a work along the same lines but with a narrower focus, *New Jersey's Civil War Odyssey*, was published by the state's official Civil War Sesquicentennial Committee. Joseph Bilby and Jim Madden, coauthors of this book, contributed material to and Mr. Bilby edited *Odyssey*. Mr. Bilby is also a previous History Press author, with histories of Sea Girt and Asbury Park to his credit, the latter cowritten with another coauthor here, Harry Ziegler.

This book seeks to span the centuries with stories of New Jersey's soldiers, from the luckless "Jersey Blues" of the 1750s French and Indian War to the bloody Civil War struggle of the First New Jersey Brigade at Gaines's Mill in 1862 and the triumphant New Jersey National Guardsmen of the 102nd Cavalry, the first American troops into Paris in 1944. It covers politics as well, addressing the battles, political and physical, in the state's dysfunctional late nineteenth-century legislature

while providing a unique perspective on notorious Jersey City political boss Frank Hague. New Jersey's forgotten historical personalities in and out of politics—including three-time governor A. Harry Moore and the mysterious big-league baseball player and sometime spy Moe Berg—also get their due. There are tales of triumph and tragedy, from the Newark Industrial Exposition of 1872 to the Asbury Park fire of 1917 and the catastrophic 1951 Woodbridge train wreck. Readers also get a peek at the dark underside of the Garden State, with Ku Klux Klansmen and Nazis pushing their agendas within its borders in the 1920s and 1930s. All of these stories and more await the reader of this anthology.

All three authors, lifelong New Jersey residents, students of and active participants in the state's story, are totally smitten with the stories of the men and women, soldiers and civilians, politicians and businessmen, heroes and scoundrels who provide this composite of the Garden State's story. They hope that the reader will enjoy reading these tales as much as they did researching and writing them.

THE JERSEY BLUES

Neither a sad reflection on the state nor a 1920s jazz riff, "Jersey Blues" has been a nickname for the Garden State's fighting men for more than 250 years. New Jersey officially became a British possession in 1664, when a fleet dispatched to New Netherlands by the Duke of York seized that colony, which included present-day New York and New Jersey, from the Dutch. New Jerseyans subsequently fought in the series of wars between the British and French for domination of North America. In the last of these conflicts, the colony's soldiers would gain the iconic moniker, "Jersey Blues," that would endure to the present day.

The French and Indian War, known as the Seven Years' War in Europe, began with a frontier encounter between George Washington's Virginia provincial regiment and French forces in 1754. After Washington's defeat in July, New Jersey royal governor Jonathan Belcher requested the colony's assembly to authorize £15,000 in bills of credit to help cover the cost of the war, including funding to provide "Pay, Cloathing, and Subsistence of 500 men," organized into a provincial volunteer regiment. Command was awarded to the closest individual New Jersey had to a professional soldier: the aging Colonel Peter Schuyler, who had served in a previous war against the French. Recruits in search of adventure (or perhaps the £1 bounty offered) quickly filled the ranks. A Trenton correspondent wrote that "the Country Fellows list like mad."

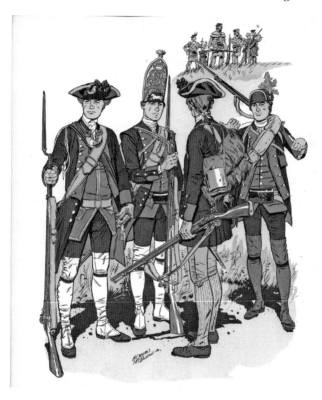

The "Jersey Blues" portrayed as they should have looked. In the field, they were no doubt much more grubby—and no doubt not as handsome. *Company of Military Historians.*

Each recruit was authorized issue of "one good sheepswool blanket, a good lapel coat of coarse cloth, a felt hat, two check shirts, two pair of Osnaberg trousers, a pair of shoes and a pair of stockings…a good firelock [musket], a good cutlass sword or bayonet, a cartouche [cartridge] box and a hatchet." A tent was issued to every five men, and the regiment as a whole was issued "fifteen barrels of pork, forty-five hundred weight of lead [for casting bullets] and other necessaries."

By the summer of 1755, in the aftermath of British general Braddock's disastrous defeat on the Monongahela in Pennsylvania, refugees from French and Indian frontier raids began to cross the Delaware into New Jersey, unsettling the residents of the northwestern part of the colony. Governor Belcher ordered militiamen to temporary active duty on the Sussex County frontier, and several hundred Sussex citizen-soldiers crossed the river to campaign alongside their Pennsylvania counterparts, but the brief expedition failed to intercept the raiders. By December,

the assembly was vainly calling for the return of New Jersey's provincial regiment to defend the northwest border.

The regiment was long gone, however. While the border simmered, New Jersey's provincials had departed for Albany, joining volunteer soldiers from New York and New England under Sir William Johnson as part of an expedition intended to capture Crown Point on Lake Champlain. Half of the Jerseymen, under Schuyler, were diverted to Oswego, on Lake Ontario, where they built and garrisoned one of three forts. In August 1756, the French commander in Canada, Major General Louis-Joseph de Montcalm, captured the Oswego forts and the Jerseyans serving there, including Colonel Schuyler. Lord Loudon, then overall commander in America, called for more assistance from the colonies, including one thousand more men from New Jersey; the assembly voted to appropriate more money and called for another five hundred volunteers but failed to meet Loudon's troop quota. It appears that the recruits, including Sergeant William McCrackan of Somerset County, who had prior service in a British mounted regiment and enlisted in 1757, replaced the losses sustained by the New Jersey unit already in the field. Colonel John Parker replaced Schuyler, now a prisoner in Montreal, in command of the New Jersey regiment, now camped at Fort William Henry, on Lake George.

On July 21, 1757, Fort William Henry's commander ordered Colonel Parker to take a 350-man force of New Jersey

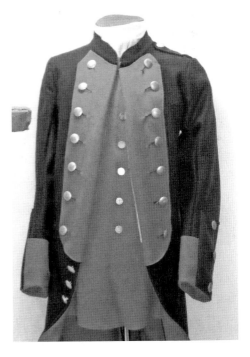

Reproduction Jersey Blues uniform based on surviving descriptions. No original uniforms from the era survive. *National Guard Militia Museum of New Jersey/Sea Girt/Joseph G. Bilby.*

and New York troops up Lake George by boat on a reconnaissance in force to capture some prisoners in an effort to determine what the French were planning. At Sabbath Day Point, the expedition was ambushed by a force of French and Indians who opened fire from shore and then encircled Parker's force with canoes. The provincials panicked, losing 160 men killed or drowned and many of the remainder captured, although Parker managed to escape with 100 survivors. The French lost one man wounded. A French officer later claimed that Ottawa Indians subsequently dined on at least one unfortunate Jerseyman. Fort William Henry, with 301 Jerseyans remaining in the garrison, fell to the French in August after a brief siege. A subsequent Indian attack on the surrendered and paroled garrison marching to Fort Edward (vividly portrayed in *Last of the Mohicans*) resulted in additional New Jersey casualties, including Sergeant McCrackan, who was carried off to Canada as a prisoner and later ransomed by the French.

By the terms of the capitulation, the Fort William Henry garrison, including 239 Jerseymen who survived Sabbath Day Point, the siege and the massacre, were forbidden to bear arms against the enemy for an eighteen-month period. McCrackan found himself, along with some of the Oswego prisoners, transferred to France. He was eventually exchanged but was then stranded in Ireland through 1763, until he had earned enough money to pay for his passage home. Perhaps all of the tribulations proved too much for Governor Belcher, who, ailing for some time, died on August 31.

As 1757 waned, the New Jersey regiment began to recover from its multiple disasters. Colonel Schulyer was paroled by the French that summer and, after a hearty welcome home to his estate, Petersborough, on the Passaic River outside Newark, including "bonfires, illuminations, cannonading, and health drinking," set about arranging a permanent exchange for himself and other prisoners. Unfortunately, he failed and, in June 1758, returned to captivity until he was officially traded for a captured French officer of equal rank in November. In his absence, the colony raised more men to restore the unit destroyed at Oswego and Fort William Henry. Recruits, at least some of whom may have been survivors of the initial regiment, were provided with "a cloth pair of breeches, a

A mid-1950s postcard image of the reconstructed Fort William Henry. No Jersey Blues are manning the wall, but the original unit was indeed part of the garrison and suffered heavy casualties in the Lake George fighting. *Joseph G. Bilby.*

white shirt, a check shirt, two pair of shoes, two pair of stockings, one pair of ticken breeches, a hat, blanket, canteen and hatchet for each recruit, under a bounty of £12." The significant bounty, compared with the £1 previously offered, was intended to head off a draft from the militia requested by the British command in America. The new soldiers would also be paid £1.13s.6d per month plus "a dollar to drink his Majesty's Health" upon enlistment.

The men of the revived regiment, which left for Albany under the command of Colonel John Johnson in May, were probably the first Jerseymen who could accurately be called "Jersey Blues." Although the color of the clothing issued to previous recruits was not detailed, this group was dressed in "[u]niform blue, faced with red, grey stockings and Buckskin Breeches." One account has the regimental coat tailored "after the Highland manner," or cut short. Although another source maintains that the "Jersey Blue" nickname was used as early as 1747, the first documented record is in a letter dated in June 1759. In addition to raising new troops, the assembly voted to build barracks in Elizabeth, Perth Amboy, New Brunswick, Trenton and Burlington to house British

regular army soldiers rather than quarter them in private homes. The Trenton barracks alone survives to this day, the only remaining French and Indian War barracks in the United States.

The "Blues" were engaged in yet another military misfortune in July 1758, when the British army under General James Abercrombie bungled an attempt to capture French Fort Carillon (Ticonderoga) on Lake Champlain. Although Abercrombie's army of sixteen thousand men, including the Jersey provincials, vastly outnumbered the French, a series of British frontal assaults on a French defensive line near the fort proved disastrous. Fortunately for the Jerseymen, they did not participate in the major thrust of the attacks, although they still lost Lieutenant Colonel Thomas Shaw of Burlington (who, as a captain, had survived the Fort William Henry debacle), along with ten other men killed and forty-four wounded. In the wake of his defeat, Abercrombie was replaced by General Jeffrey Amherst, and the tide of war began to turn in favor of the British, who captured Louisbourg and Forts Frontenac and Duquesne.

Following a succession of British victories, recruiting offices opened in Salem, Gloucester, Burlington, Bordentown and Newton as New Jersey raised more volunteers to serve in New York and Canada. New Jersey volunteers were also part of the British force that attacked Havana in 1762. In all, one scholar estimated that as many as three thousand men served in provincial forces of one kind or another or in the British regular army (which regularly enlisted colonists in its ranks) between 1755 and 1763, "a level of participation requiring the enlistment of every fourth free male between the ages of sixteen and forty-five who was not a Quaker." When the war ended in 1763, with British dominance in North America assured, it would seem that the future of the Royal Colony of New Jersey—securely tucked within the empire and with a military potential greatly enhanced by the war, which provided experience and training for both officers and enlisted men of a once ramshackle militia—would be secure. Perhaps, but not for long. Within a decade, Jerseymen would be fighting in another war—on both sides.

The nickname "Jersey Blues" has endured, and it has surfaced again almost every time Jerseyans have gone to war. During the Civil War, Trenton poet Ellen C. Howarth penned "My Jersey Blue," an ode to the state's soldiers, and the name has appeared as part of the insignia of the

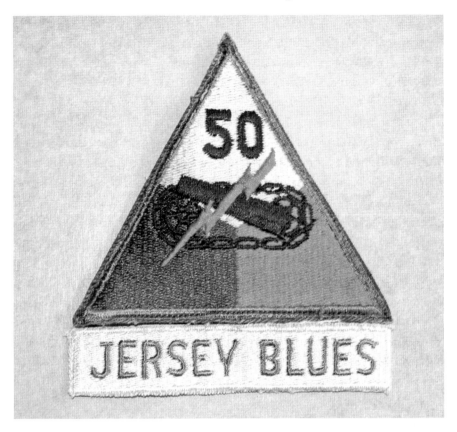

A patch from the 1950s National Guard, "Jersey Blues." *Joseph G. Bilby.*

New Jersey National Guard's Fiftieth Armored Division shoulder patch in the 1950s and its current Fiftieth Brigade patch. It will, no doubt, endure as long as New Jersey's soldiers endure, a silent tribute to the sacrifices of Colonel Schuyler, Sergeant McCrackan and their comrades in the long ago.

Perhaps surprisingly, there has been no substantive work on the French and Indian War Jersey Blues until recently. Greg Casterline did an admirable job of assembling the available primary and secondary sources in one volume with his Colonial Tribulations: The Survival Story of William Casterline and His Comrades of the New Jersey Blues Regiment, French and Indian War, 1755–1757 *(Lulu On-Line Publishing, 2007).*

"SCOTCH WILLIE" MAXWELL

New Jersey's Forgotten General

In December 1776, before his triumph at Trenton, George Washington assigned Brigadier General William "Scotch Willie" Maxwell to report to the secure American base at Morristown and begin reorganizing New Jersey's Continental army regiments. Maxwell was also assigned the job of operating alongside General Philemon Dickinson's New Jersey militia with his recruits as part of the harassment campaign against remaining British garrisons in the state. Scotch Willie, who set up headquarters on the east side of the Watchung Mountains in Westfield, fulfilled his mission with an enviable competence.

Born in 1733, Maxwell was one of the most interesting brigade commanders in the Continental army. A Scotch-Irishman who had moved with his family from County Tyrone to Sussex County, New Jersey, in 1747, Maxwell served as a junior officer in the "Jersey Blues" in the French and Indian War and then as a "king's commissary," supplying British garrisons on the frontier from Schenectady to Michilimakinac, on the Straits of Mackinac, separating Lakes Michigan and Huron.

Maxwell, a tough frontiersman with a Native American common-law wife and a reputed fondness for whiskey, returned to New Jersey in 1774 to participate in the events leading up to the Revolution. He was a member of the New Jersey Provincial Congress in October 1775, when he was appointed colonel of the Second New Jersey Regiment, which he

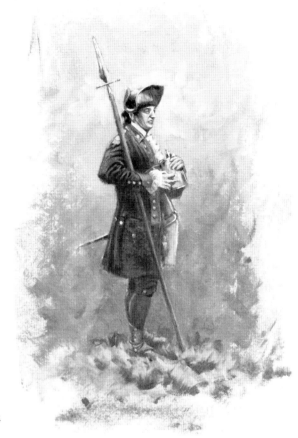

An officer of the Third New Jersey Regiment of Scotch Willie's New Jersey Brigade, circa 1778, in the Revolutionary War, as portrayed by New Jersey artist Peter Culos. The weapon he carries is a "spontoon," which can be used horizontally to keep troops in line or vertically as a weapon. *Peter Culos.*

led in the American invasion of Canada. Upon his return to New Jersey from that disastrous campaign, he was promoted to brigadier general and received his assignment from Washington.

Maxwell, it turned out, had a particular genius for the hit-and-run style of warfare needed to harass the British in New Jersey in 1777. He used his more disciplined Continental regiments to stiffen the militia at critical junctures, cooperating with Dickinson in what proved to be a seamless campaign.

On February 23, 1777, Colonel Charles Mawhood led a strong British force from Perth Amboy to Rahway, and Maxwell gave him a fight that he would not soon forget. Mawhood tried to outflank a line of

militiamen with soldiers from the Forty-second Foot, a highly regarded Scottish Highland regiment, but Scotch Willie had quietly deployed an unseen detachment in a position outflanking the Scottish advance. At the appropriate moment, the Jerseymen rose up and shot the regulars to ribbons, after which the whole British force fell back toward Amboy, harassed by Continentals and militiamen along the way. Two weeks later, Maxwell repeated his performance against another enemy column. Historian David Hackett Fischer calculated that over the winter, following the Battles of Trenton and Princeton, General William Howe's British army lost "more than nine hundred men…killed, wounded, captured or missing" in its "Forage War" operations in New Jersey in 1777. That damage was inflicted by the aggressiveness and growing military skill of the New Jersey militia and Continentals led by Dickinson and Maxwell.

After the British garrison in New Jersey withdrew to New York in the summer of 1777, a large British force under General William Howe sailed south to Maryland and began to move north toward Philadelphia. Washington marched to meet the enemy and created an elite battalion of physically fit and courageous "picked men" to engage the British advance. Maxwell proved a natural choice to command the outfit, and the Jerseyman was instructed by Washington to "be watchful and guarded on all the roads," to "annoy the enemy whenever possible" and to be careful when and where he fought, only engaging the British when he had a good chance of success.

On August 30, Maxwell deployed his seven hundred soldiers near Cooch's Bridge on Christiana Creek in Delaware. The Jersey general established a defensive line extending from the bridge along Iron Hill and then sent most of his men forward down the Aiken's Tavern Road, the main axis of the British advance. They made contact with the enemy on the morning of September 3, conducted a two-mile fighting withdrawal to Cooch's Bridge, made a short stand and then retreated again, through woods and across fields and up the slope of Iron Hill. At that point, General Howe personally appeared on the field with reinforcements and artillery and ordered an all-out attack on the American position. Outgunned and outnumbered, Maxwell's men, who had battled the British for seven hours, fled the field, some tossing away their blankets

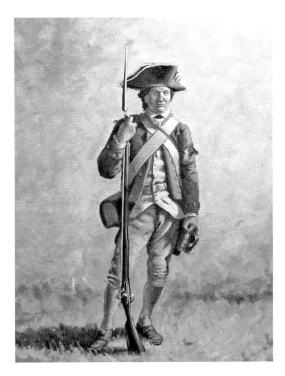

An enlisted man of the Second New Jersey Infantry of Maxwell's Brigade, circa 1778, as portrayed by New Jersey artist Peter Culos. By the middle of the war, the brigade's enlisted men wore a mix of civilian and military clothing, some of it in ill repair. *Peter Culos.*

and muskets. The young and inexperienced Marquis de Lafayette, who had watched the last stages of the fight along with Washington, was critical of Maxwell's conduct, but the American commander thought that the Jersey general had done a fine job before retreating in the face of overwhelming odds.

Maxwell would have his revenge, as his men ambushed the British advance guard the following morning and in a vicious fight killed or wounded half the enemy force. Once again, however, overwhelming odds eventually pushed the Americans back and across Brandywine Creek in the opening stages of the Battle of Brandywine. Washington lost the battle, but not due to any failures on the part of Maxwell. Following the British capture of Philadelphia, the American commander attempted a counterattack at Germantown, where Maxwell, back in command of his old brigade, performed well in what proved to be, unfortunately, yet another defeat.

Scotch Willie and his Jerseymen spent the hard winter of 1777–78 at Valley Forge. Maxwell had a few rough spots over the winter: he was

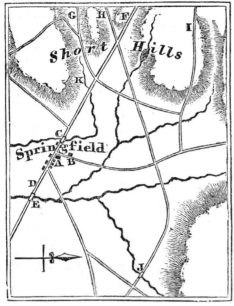

Plan of the

Battle of Springfield, fought

June 23, 1780.

[*References.*—A. Church. B. Parsonage. E. First bridge on the main road. C. Second bridge. J. Vauxhall bridge, or Little's. D. Station of the American troops, on rising ground. F. Principal pass over the Short Hills. H, G, I. Other passes. K. High grounds and mill, supposed to be the same as the first range of hills in rear of Byram's tavern.

NOTE.—This map was drawn in 1842.]

Map of the Battle of Springfield, Scotch Willie's last fight. *Gordon Bond.*

found innocent at a court-martial accusing him of being drunk during the Brandywine fight and survived further lobbying by some of his feuding officers, all of them related by blood or marriage to the elite Elizabethtown Ogden family, to have him removed from command. By spring, however, he was ready for action. Following a rollicking celebration in which the men of the Jersey Brigade, some dressed as Indians and well fortified with whiskey, marched, their hats adorned with cherry blossoms, with "mirth and Jollity" in honor of "King Tammany," the army gathered on May 6 for a formal announcement of the French alliance, followed by salutes of cannon fire and a musketry "feu de joie."

Two days later, Maxwell's brigade crossed the Delaware into New Jersey and went into camp at Mount Holly. The brigade, recently reinforced by drafted militiamen, numbered about 1,300 soldiers, although many were inexperienced. They would learn soldiering on the job. Maxwell and his officers drilled the draftees, who continued to arrive in small groups through early June, by "introducing the Baron de Steuben's Instructions."

The British army under Sir Henry Clinton abandoned Philadelphia on June 18, 1778, and began a march across New Jersey to New York. The New Jersey militia and Maxwell's Continentals, using a style of warfare the Jersey general had mastered in 1777, badgered them on their way. The Jerseymen pulled up bridge planking, filled in wells and delivered a sporadic stream of musketry into the enemy line of march. A Hessian captain recalled that "the skirmishing continued without letup."

While Maxwell and the militia harassed the British, Washington marched into New Jersey with his main army, and both forces clashed at Monmouth Courthouse on June 28 in the longest battle of the Revolution—and the first one where the main American army stood toe to toe with the British and held the field at the end of the day. The New Jersey Brigade was engaged at Monmouth but suffered limited casualties. Following the battle, Maxwell's Jerseymen marched to Elizabethtown, where they were stationed to keep a watch on British activity on Staten Island and provide a trained defensive force to reinforce the militia in case of enemy raids or incursions into eastern New Jersey.

In 1779, Maxwell led his brigade in General John Sullivan's campaign against the Iroquois in Pennsylvania and New York but was back in New Jersey by the winter. The following June, he would engage in his, and New Jersey's, last big fight of the Revolution. On June 6, a British and Hessian force of six thousand men landed at Elizabethtown in an attempt to drive to Springfield and through Hobart's Gap to Morristown to attack the main American army, which was recovering from its worst winter encampment. The enemy had pushed back a combined force of Jersey Continentals and militia under Colonel Elias Dayton to Connecticut Farms (today's Union) when Scotch Willie arrived on the scene with more militiamen and the remainder of his brigade. By this stage of the war, Maxwell was perhaps the best man in the army to command in such a situation. His experience combining militia and Continentals over three campaigns stood him in good stead.

Maxwell's vastly outnumbered men held the British advance guard for three hours and then fought from house to house, fence row to fence row and woodlot to woodlot, gradually withdrawing beyond Connecticut Farms and across the Rahway River toward Springfield before the

enemy advance. By nightfall, June 7, the British were stalled, with hopes of a surprise dash through Hobart's Gap gone. The following day, they withdrew to Staten Island, retaining a beachhead at Elizabethtown. In a second invasion of New Jersey on June 23, Maxwell, then working under General Nathanael Greene, was part of the force that again turned the enemy back, this time at Springfield, in last major British incursion into New Jersey.

Following the Battle of Springfield, Scotch Willie Maxwell was worn out from fighting the British and victimized by the political backbiting of the Ogden cabal, once again plotting to have him removed from command of a brigade that was shrinking in size and, therefore, officer assignments; he soon resigned his commission. He retired to Greenwich Township in Warren County, where he lived in some comfort on the family farm and served in the New Jersey Assembly in 1783. Although maligned over the years by some, accused of being a drunkard by others and forgotten by most everyone, Scotch Willie was one of New Jersey's most talented generals. He died on his farm in 1796 and was buried at the First Presbyterian Church burial ground in Greenwich.

The best-detailed account of Scotch Willie's career is Harry M. Ward's General William Maxwell and the New Jersey Continentals *(Greenwood Press, 1997).*

THE GREAT HOBOKEN HUMBUG

Famed nineteenth-century American showman Phineas T. Barnum proudly proclaimed himself the "Prince of Humbugs." In the lexicon of the time, a "humbug" was a public attraction that demonstrated mastery of the arts of advertising and entertainment by its promoter. The true humbug event was peculiar and novel and of such low cost to both the promoter and his audience that it was not perceived as a fraud or an outright hoax no matter its dubious content. The humbug spectators could learn that they were fooled but not mind, since they were amused at little apparent cost to themselves, while at the same time the promoter pocketed a tidy sum through ancillary means.

While visiting Boston's Bunker Hill commemoration in June 1843, Barnum spotted a herd of fifteen scrawny and malnourished bison calves on exhibit. He recalled, years later, that they were "weak and tame," but he instantly realized that given the American public's fascination with, yet overall ignorance of, the far west and its fauna, he could bill them as ferocious wild beasts—and that there was a dollar to be made in doing so. He would, he decided, stage a "Grand Buffalo Hunt" to entertain the public.

Barnum purchased the scrawny herd for $700 and hired its former owner, C.D. French, as a handler at the then substantial salary of $30 per month. French not only knew how to take care of the animals but was also an accomplished artist with the lasso. Barnum characteristically settled on

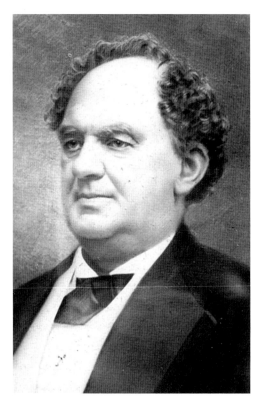

Phineas T. Barnum, whose Hoboken "humbug" kick-started a career. *James M. Madden.*

an exotic theme for his show. He decided to dress French in Native American garb and promote him as "one of the most daring and experienced hunters of the West," who had personally captured the beasts near Santa Fe. Barnum envisioned a performance in which French would ride on horseback around an arena demonstrating his roping skills on the hapless young bison. Advertised as the first live reenactment of an authentic western buffalo hunt, it would surely appeal to an eastern urban audience.

With his headquarters in Manhattan, Barnum quartered the herd in a barn and looked around for a nearby venue for this, one of his earliest humbugs. Hoboken, New Jersey, was still a rural town with plenty of open land, and it was but a brief ferry ride across the Hudson for New Yorkers seeking escape from their crowded and hectic city in search of more rural entertainment. The wealthy Stevens family owned a racecourse on the New Jersey shore a few yards from the ferry slip, which would provide an ideal setting for Barnum's show. His plan was not to sell tickets to the event but rather to offer it to the public for free.

After securing the venue, the showman approached several Hudson River ferry operators and offered to charter their boats for a day for more than the usual daily receipts, for the sole purpose of bringing his customers to Hoboken. In order to get to his free event, New Yorkers would have to pay to cross the river on the ferries, while New Jerseyans could only attend via a fee-paid carriage ride. In addition, Barnum had

an interest in the concession stands catering to the crowd. Every person attending the "free" event would actually be paying Mr. Barnum, through some third party, for the privilege.

Once financial arrangements were in place, Barnum launched a publicity blitz in magnificent style, plastering posters and distributing handbills all over New York City and northern New Jersey. The promotional literature featured an illustration of wild buffalo being pursued by a mounted Indian but did not reveal the name of the sponsor of Hoboken's "Grand Buffalo Hunt." Once interest was suitably aroused, Barnum carefully leaked some details to the newspapers, helping to stimulate more public interest as journalists wrote about what a bargain the "free" event would be.

The date of the hunt was set for Thursday, August 31, 1843. It was warm and calm that morning as ferries pushed off from three different Manhattan locations, carrying the first wave of the immense crowds that began to swarm the docks, anxious to get a glimpse of the simulated prairie life on display across the river. More ferries were added, and they all sailed crammed with passengers, some hanging on to the railings. Unsurprisingly, there were problems. Two drunks fell overboard and nearly drowned, and a number of fights broke out. The fare was six and one-fourth cents one way, or twelve and a half cents round trip, so Barnum was raking in cash, although his customers did not suspect a humbug, as they were simply paying the regular ferry fare. It was estimated that more than twenty-four thousand New Yorkers crossed over to see the "Grand Buffalo Hunt." Thousands of New Jerseyans came overland to join them.

The Stevens racecourse was in a field set in a natural depression, enabling some spectators to sit or stand on a hill and look down on the course. Two rows of fencing were erected to keep the bison from fleeing into the Jersey countryside and also to keep intoxicated observers off the field. Other entertainment in the way of "sporting attractions" and a brass band diverted the attendees throughout the day until the start of the grand event at 3:00 p.m. At that hour, doors opened on a shed adjacent to the field, and the bison calves were prodded out into the bright sunlight, where they huddled together in a group, looking remarkably docile.

French, bedecked in Indian garb, rode up and began to poke the animals with a sharp stick to get them moving. Jeers and laughter broke out in the audience, but French and several other wranglers were eventually able to push the herd into an ambling trot around the track, which caused a great deal of excitement. As the buffalo charged in one direction, the crowd squealed in delight or terror, rushing to get out of the way in fear of being trampled should the beasts break out of the enclosure. As some people fled, others ran down for a better view, leading to a great deal of jostling and confusion. The resulting mob scene, with people waving their arms and hats, as well as taunting the bison, caused the already terrified animals to dart here and there, seeking a safe corner to retreat to. The pushing and shoving culminated when a surge of spectators collapsed one portion of the fence, and the herd made a quick escape through the resulting opening, heading toward a swampy field while the crowd fled in all directions.

Bedlam ensued. A young Irishman climbed a tree to escape the chaos, but the branch he perched on broke, dropping him to the ground and resulting in his death. A woman with a child in her arms who was standing on the hill near the course was so frightened by the approaching animals that she slipped and fell backward, tossing her infant into the air. Luckily, a bystander was able to catch the child before it hit the ground, but the mother was severely injured. Another woman was knocked down by the fleeing mob and was almost trampled by a buffalo, which managed to tear off a large section of her dress. The animal ran away with the ripped fabric entangled in its horns and flapping in the wind. One wag witnessing the incident bizarrely joked to a newspaper reporter that "she surely wouldn't need a shaggy buffalo robe in this warm weather."

Mr. French took charge of the situation and rode close behind the escaping herd. Although temporarily mired in the morass, he managed to successfully lasso a bogged-down bison and drag it out of the muck, much to the delight of the audience. Order was restored as French and his assistants successfully roped the rest of the beleaguered animals and returned them to captivity.

Overall, despite the less than ferocious buffalo, the spectators enjoyed the show, and apparently none felt cheated as they all boarded ferries back

to the city. Passengers on one packed craft leaving late from Barclay Street announced to those on an arriving ferry that the performance was all a great humbug and not the expected Wild West—but since it was free, they had had a great and exciting time. Barnum later remarked that he got his own biggest laugh while "watching the people run and screech with fear, when the little harmless calves broke through the fence, and were scampering for the swamp." Fortunately for the impresario, personal injury lawsuits were not yet in style.

Barnum successfully ran his buffalo humbug again in Camden, New Jersey, at the end of September, drawing the denizens of Philadelphia across the Delaware this time. The results were the same, even to the crowd knocking over the railing (coincidence?) and allowing the bison to escape before they were rounded up. Fortunately, no injuries or deaths were reported this time, but Barnum made another tidy profit. Eventually, some of the buffalo were shipped

GRAND BUFFALO HUNT
FREE OF CHARGE

At Hoboken, on Thursday, August 31, at 3,4, and 5 o'clock P.M.

☞ **Mr. C.D. French,** one of the most daring and experienced hunters of the West, has arrived this far on his way to Europe, with a **HERD OF BUFFALOES,** captured by himself, near Santa Fe. He will exhibit the method of hunting the Wild Buffaloes, and throwing the lasso, by which the animals were captured in their most wild and untamed state. This is perhaps one of the most exciting and difficult feats that can be performed, requiring at the same time the most expert horse-manship and the greatest skill and dexterity.

Every man, woman, and child can here witness the wild sports of the Western Prairies, as the exhibition is to be free for all, and will take place on the extensive grounds and Race Course of the Messrs. Stevens, within a few rods of the Hoboken Ferry, where at least fifty thousand ladies and gentlemen can conveniently witness the interesting sport.

The Grand Chase will be repeated at three distinct hours. At 3 o'clock P.M., from twelve to twenty Buffaloes will be turned loose, and Mr. French will appear dressed as an Indian, mounted on a Prairie Horse and Mexican saddle, chase the Buffaloes around the Race Course, and capture one with the lasso. At 4 and 5 o'clock, the race will be repeated, and the intervals of time will be occupied with various other sports. The City Brass Band is engaged.

No possible danger need be apprehended, as a double railing has been put around the while course, to prevent the possibility of the Buffaloes approaching the multitude. Extra ferry-boats will be provided, to run from Barclay, Canal, and Christopher streets. If the weather should be stormy, the sport will come off at the same hours the first fair day.

W. Applegate, printer, 17 Ann-Street, 1843

Barnum publicized his "humbug" all over New York and northern New Jersey. *James M. Madden.*

A real Buffalo hunt is expected to come off somewhere in this vicinity in the course of a few days—a gentleman from the wilds of the West being on his way hither with a number of these wild animals. It will be rare sport for the inhabitants of this city to witness the exciting scene of chasing and catching with the Lasso these animals. Thousands of ladies, gentlemen and even children will be delighted with the exhibition.

If the Messrs. Stevens would have it come off at Hoboken, free of charge, their ferry boats would bring them in thousand of dollars, and they would require half a dozen extra boats.

Selective leaks to the newspapers produced articles like this one in the New York American. *James M. Madden.*

to England, perhaps destined for zoos, while others, less fortunate, were fattened up and slaughtered for steaks at New York's Fulton Market.

Despite his outlays for purchasing the bison, chartering the ferries, handler salaries and other event expenses, Barnum did well, clearing well over $3,500 for Hoboken's free "Grand Buffalo Hunt." Even more beneficial for the showman's future promotions were the positive words from spectators and newspapers alike, once he emerged from the shadows to proudly proclaim his role in the event. The Hoboken show provided Barnum with a great deal of free publicity for his American Museum in New York City and set him on the road to success. Although long forgotten, in contrast to the much ballyhooed first baseball game at Elysian Fields in 1846, credit is also due Hoboken for launching a famous American career—with a humbug.

Phineas T. Barnum told his own story numerous times, most notably in his Struggles and Triumphs *(American News Company, 1871). This publication, as well as contemporary newspaper accounts in publications as diverse as the* New York Sun, London Punch *and the* Alexandria (VA) Gazette, *served as sources for this section.*

"I RATHER THINK SOME OF US WILL NEVER COME OUT"

In the spring of 1862, Major General (and future New Jersey governor) George B. McClellan moved his Army of the Potomac to the Virginia Peninsula to attack Richmond. The First New Jersey Brigade, under the command of General George W. Taylor of Hunterdon County, moved south with the army. The brigade—composed of the First, Second, Third and Fourth New Jersey Volunteer Infantry Regiments and supported by Captain William Hexamer's Battery A, New Jersey Volunteer Artillery—landed at West Point, Virginia, on the York River, on May 6.

McClellan inched his large army toward Richmond, dividing it north and south of the Chickahominy River. Following the inconclusive Battle of Seven Pines on May 31, the Confederate army opposite him came under the command of General Robert E. Lee. On June 26, Lee attacked Major General Fitz John Porter's Fifth Army Corps, isolated north of the Chickahominy, at Mechanicsville, and Porter retreated to a better defensive position near Gaines's Mill. On June 27, Major General Ambrose P. Hill's Rebel division assaulted the Fifth Corps' center at Gaines's Mill, while other Confederate units engaged the Yankee right wing. Both sides settled into a battle of attrition, and as the day wore on, the outnumbered Fifth Corps men began to falter.

At 5:10 p.m., the First Division of the Sixth Army Corps, including the Jerseymen of the First Brigade and Hexamer's artillerymen, crossed the

General George Taylor commanded the first New Jersey Brigade at Gaines's Mill. *John Kuhl.*

Chickahominy to reinforce Porter. By the time the Jersey Brigade arrived on the field, Porter had already committed all his reserves to the fight, and the Sixth Corps soldiers were deployed just behind the battle line.

General Taylor formed his regiments into two lines of battle, with the Third and Fourth New Jersey in front and the First and four companies of the Second New Jersey (six companies of the Second remained behind on guard duty across the river) to their rear. The brigade's position was slightly to the left of the Union center and several hundred yards from a tree line marking the front. Hexamer's gunners dropped trails to the right of the infantry and began firing shells at distant Confederates, setting their fuses for 1,100 yards. While Taylor was deploying, a staff officer galloped up and gave the Jersey general orders in French. The confused general turned to his aide, First Lieutenant E. Burd Grubb of Burlington, who spoke the language, and asked, "Who the devil is this, and what is he talking about?" The lieutenant identified the officer as the Comte de Paris, from McClellan's staff. The Frenchman requested a regiment to fill a hole farther down the line, and Taylor gave him Colonel James Simpson's Fourth, which the staff officer led off toward the woods.

Shortly after Simpson departed, General Porter rode up to the Jerseymen and ordered Taylor to "Go in!" Lieutenant Colonel Robert McAllister's First

and Colonel Henry Brown's Third New Jersey advanced into the woods four hundred yards to their left front. The four companies of the Second, which had initially supported Hexamer's guns, were also sent forward, but separately, to support a Michigan regiment. As the Second filed in behind the Wolverines, Colonel Isaac M. Tucker noted to a fellow officer that "[t]hings are rather hot in there, and I rather think some of us will never come out."

The First and Third sloshed across a swampy woodlot, quickly engaging the Rebels and driving them out, but retreated under heavy fire from enemy reserves in an open field beyond. After falling back,

Lieutenant E. Burd Grubb served as Taylor's aide during the battle. *John Kuhl.*

the Jerseymen stood fast, keeping the enemy in front of them pinned down. Taylor's men were able to deliver a high rate of "firm and decided fire" due the combustible paper cartridges they had been issued. The cartridges were rammed down the barrel of their muzzleloading rifle-muskets whole, unlike the regulation paper cartridge, the end of which a soldier had to bite off before pouring powder down the muzzle and then separately ramming down a conical bullet. Some soldiers did not even bother to ram their "Patent Inflammable Cartridges." One man recalled that "after the pieces [rifle-muskets] had become warm it was only necessary to insert the cartridge, give the piece a slight shock, and it was home, thus greatly facilitating the rapidity of reloading." Lieutenant

Captain William Hexamer of Hoboken commanded Battery A, First New Jersey Artillery, at Gaines's Mill. *John Kuhl.*

Grubb believed that the combustible ammunition was the same as that issued for reloading steel cases used in the "Union Volley" or "Coffee Mill" gun, a primitive machine gun, several of which were deployed at Gaines's Mill and manned by Jerseymen.

The Rebels began to work their way in close. An officer of the Third New Jersey spotted a Confederate in a tree twenty yards away, snatched a rifle-musket from one of his men and shot him. Over the next ten minutes, he hit two more. Jerseymen were dropping as well, and wounded and dead soldiers were carried to the rear in a slow but steady stream. Since most of the Confederates were shooting obsolete smoothbore muskets loaded with "buck and ball" ammunition, many of the wounds were caused by buckshot and were not serious. They did, however, diminish the defense by causing men to leave the firing line.

The front seemed stabilized, but General Lee was waiting for reinforcements, and by early evening, when they were ready, Lee ordered all of his troops to move forward for an all-out assault. At 7:00 p.m., "an

ominous silence" descended on the battlefield. As the enemy fire abated, so did that of the Jerseyans, although an impenetrable veil of powder smoke hung heavy in the humid summer air. Taylor's men were dripping with sweat and begrimed with gunpowder residue and mud. Many who had been loading and firing from the prone position rose to their knees or stood up and peered into the haze, through which, at that moment, General Thomas J. "Stonewall" Jackson's veterans were advancing. A distinct command to "aim" and "fire" echoed from the brigade's front, and a deadly shower of bullets poured into the unprepared Jerseymen, as the brigades of Generals John Bell Hood and Evander Law rolled over the wreckage of the previous Confederate attack and surged toward their position. Stunned, with Rebels suddenly appearing on their right and left flanks, the men of the First and Third broke for the rear. General Taylor, who was dismounted, scrambled through the woods for his horse and galloped after his men to prevent a rout.

It took Taylor a quarter of a mile, and he was almost thrown when his mount balked at a ditch, but the general, swinging his sword in the air, got his men back in line and linked up with some survivors from the Second New Jersey's detachment, one of whose color bearers, covered with blood from his shot-away lips, passed his flag to Lieutenant Grubb, who waved it from horseback to signal a rally point.

It was remarkable that any men from the Second escaped from their position. When the line began to give way, Colonel Tucker was shot dead, fulfilling his own prophecy, and Major Henry Ryerson pulled the survivors out, retreating through a crossfire from friend and foe alike to a hill behind the woods, where he was promptly shot himself.

Among those cut off at the breakthrough point was Captain Franklin Knight of the Third. Knight surrendered to a Confederate and then changed his mind when the Rebel clubbed him with a musket butt. Since Knight had not yet been disarmed, he pulled his revolver and shot his way to freedom. Not everyone made it back. Corporal Charles Hopkins of the First, twice wounded himself and cut off by Confederates, carried Sergeant Richard Donnelly through a blizzard of bullets to what he thought was a place of safety but then was again wounded in the head. Both men were captured, but Hopkins's selfless heroism earned him a Medal of Honor.

Colonel James H. Simpson led the Fourth New Jersey Infantry at Gaines's Mill. He was captured along with most of the men in the regiment. *John Kuhl.*

Hexamer's artillerymen were almost overrun as their infantry support fled the field. The Hoboken captain held his ground, however, and then retreated in good order. He lost one gun but did far better than other Union artillery units that day. The fire of the "Coffee Mill" machine guns, crewed in part by Jerseyans from the Third under Sergeant James Dalzell, caused barely a ripple in the Confederate tide, and the guns would soon be on display in Richmond.

The Fourth New Jersey, fighting on its own hook and isolated from the brigade, did not get the word to retreat. Colonel Simpson's men fought on until, low on ammunition, they were relieved by a Pennsylvania regiment. Simpson saw large formations of troops to his rear and sent Lieutenant Josiah Shaw to see who they were. When Shaw returned with his clothes full of bullet holes, Simpson had his answer. The colonel tried to fight his way out but, totally surrounded, was forced to surrender his regiment. When Taylor, who had rallied the remains of his brigade, asked Lieutenant Grubb where the Fourth was, Grubb answered him with, "Gone to Richmond, sir."

Reinforcements arrived, the line was stabilized and the remains of the Union force retreated south of the Chickahominy, leaving an equally

disorganized, albeit victorious, enemy force on the field. The First New Jersey Brigade had marched into battle that afternoon with 2,300 men. When it returned that night, 1,072 were left behind killed or wounded or as prisoners. The little detachment of the Second New Jersey suffered 50 percent casualties. The ultimate list would not be as severe, however; the Fourth's 437 prisoners would be exchanged in August, and prisoners from other units would return over the summer. The First Brigade would rise from the ashes to fight again, down all the days of the war to April 1865. The brigade's lean, sun-bronzed veterans, nicknamed, as were their predecessors, "Jersey Blues," would soldier on to become one of the best outfits in the Union army. The Jerseymen had, in the vernacular of the day, "seen the elephant" in their first battle at Gaines's Mill, and now they would ride him wherever he took them.

The standard history of the First New Jersey Brigade is Camille Baquet's History of the First Brigade, New Jersey Volunteers from 1862 to 1865 *(Trenton, New Jersey, 1910). It has been reprinted several times. A modern history of note is Bradley M. Gottfried's* Kearny's Own *(Rutgers University Press, 2005).*

THE GREAT JERSEY CITY
HAUNTING

The war was over. It had taken the lives of thousands of Jerseymen, and thousands more came home maimed in body and soul and would not recover their prewar selves for years, if ever. There was both joy and sadness in the air across New Jersey.

And then, in September 1865, a ghost, perhaps a soldier's lost soul seeking rest, took up residence in St Boniface's Church in Jersey City and adamantly refused to be exorcised. The Gothic Revival Roman Catholic Church, named after the patron saint of Germany, was intended to serve a German immigrant parish founded in 1863. The cornerstone of the church building, located on South Eighth Street, north of Jersey Avenue, was laid in May 1865, and the edifice was approaching the final stages of construction, with the first mass held in July. In mid-September, however, Saint Boniface became the cause of a number of sleepless nights of terror in downtown Jersey City.

Neighboring citizens awoke in the deep stillness of the night, "when church yards yawn and the graves give up their dead," according to one narrative, alarmed by eerie screams, unearthly yells, piercing shrieks and horrible groans. Springing from their beds, they rushed to their windows expecting to discover some brutal crime taking place in the street. But there was no crime. The ghoulish symphony, which began after midnight and resumed off and on at intervals of several hours until daylight, was emanating from Saint Boniface. After several nights of sinister clamor, excitement grew and rumors

of the new haunted church in Jersey City spread across northeastern New Jersey. The parishioners formed a committee to investigate the phantom, whose evening performances were becoming a serious problem. The committee members were befuddled in their attempt to find an explanation.

Newspaper reporters gathered on the scene, and their articles attracted even more attention from other cities. Hundreds of men, women and children now began to assemble in front of the church nightly, satisfying a morbid curiosity to hear the demonic spirit in action. No one dared venture inside, however, out of fear of meeting the source of the howling face to face. One New York reporter crossed the Hudson hoping for a personal scoop on the story. After milling around with the late-night crowd for several hours, he left sadly disappointed, cynically commenting that the whole scenario was likely a ruse by a local tavern owner, who seemed to be the only one cashing in on the mass of onlookers, who were lapping up "his bad whiskey which was otherwise unmarketable."

As the crisis dragged on over several days, the story grew. Some onlookers claimed to see red lights or eerie eyes peaking from the church steeple. One local butcher asserted that his daughter, out in search of the phantom one night, spotted a ghostly figure floating at the top of the church waving its hands over the spires. As proof of her eerie encounter, he produced a Belgian block paving stone that he claimed had narrowly missed the girl's head when the spirit threw it at her. Locals who knew the butcher suggested, however, that the only spirit involved in that story was the spirit of bourbon whiskey.

Whatever the source of the noise, the growing crowds and spreading stories made the clergy so uneasy that they called on the police to control the crowds and help solve their "unnatural spiritual" mystery with some professional detective work. Jersey City police chief Joseph McManus arrived on the scene and put on a brave front, boldly asserting to the crowd that he had no fears of the spirit world and heading into the church with a police posse to investigate. The chief entered Saint Boniface, loaded revolver in hand, while the spirit was "holding high carnival" with its "cacophony of hideous sounds," "infested moans" and "wild voices in addition to the cackling laughter." After a very brief inspection, McManus and his men retired rapidly, seemingly stunned and bewildered at what appeared to be, more and more, an inexplicable mystery.

Clergy and laity alike went to the police for assistance. Frank Leslie's Illustrated Newspaper/*James M. Madden.*

The problem now became serious enough to draw the attention of the Jersey City Council. The city had just come out of a very contentious municipal election in April 1865, in which Democratic mayor Orestes Cleveland had won by promising to halt a draft of Jersey City residents into the army and ended up emptying the treasury to pay enlistment bounties to a group of men later arrested for bounty jumping fraud while bounty brokers ran off with the money. Although the mayor won reelection, for several months afterward city hall was the scene of considerable animosity over the bounty scam that precipitated a bitter political struggle over council leadership and political appointments. One councilman seized on the opportunity of McManus's retreat to take political retribution while poking fun at a rival councilman who oversaw the city's police department. He introduced a resolution that read in part:

> *That one of the church edifices of our city is infested with spirits, spooks, ghosts, hobgoblins, and sundry diverse other unnatural apparitions, [and] from spectral non-existences issue certain melodious, unearthly subterrestrial and diabolical noises, sounds, thunderings and*

murmurings, by reason of which the Chief of Police and some of the policemen of our city were affrighted, stunned, and unceremoniously ejected from said church edifice, at the wee small hours of the morning, when the pall of night had overshadowed the western hemisphere; all of which statement is corroborated by our worthy chief; therefore be it

Resolved, that such unseemly, unbecoming and misbehaved mythical visitor, within the limits of our city, tending as they do to alarm old women, children and the members of the Police Department, should at once be summarily dismissed, banished and caused to skedaddle; and to that end, that the premises hereinbefore recited, be referred to the Committee on the Police with instructions to investigate the cause of such terror-striking manifestations; and should said committee find such statement be true, it shall be their duty to visit such church edifice at the hour in which "such apparitions most do congregate;" that is to say at the hour of 2 o'clock, a.m. of some day between this day and the next regular meeting of this Board; and on arriving at the threshold of said edifice, shall gird up on their loins and boldly and valiantly enter the same, proceed midway into said building, and the stentorian voice bid the base intruder "down," as Macbeth, "the ghost of Banquo" did, and should they find that the said diabolical noises, thunderings and murmurings are produced by any of the Colchesters, Davenports, or other spiritual or spirituous mediums, now so prolific in this neighborhood, the said committee shall at once report the facts to the United States District Attorney, with the request that indictments many be at once preferred, and the perpetrators of so foul and unnatural an outrage be brought to justice for practicing their art without license.

Resolved, that said committee report result of their visit to the diabolical, preternatural excrescences at the earliest practical opportunity.

Several days later, the supernatural mystery was solved, no doubt to the dismay of the councilman who was having fun and making political hay with it. The sexton of Saint Boniface discovered a small opening on the outside of the church. Upon further investigation, he discovered a half-starved hound dog caught in there by its chain collar and unable to free itself,

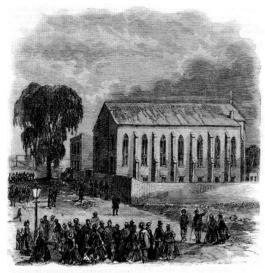

THE GREAT GHOST HOAX—THE HAUNTED CHURCH, "ST. BONIFACE," SOUTH EIGHTH STREET, JERSEY CITY

Saint Boniface. *James M. Madden.*

out of sight and under the floorboards of the church. The sexton believed the dog to be the source of the anguished howls, and once it was freed and had a good meal, the ghost seems to have left never to return. Perhaps.

In 1888, Saint Boniface's Church moved to a location on First Street and was officially closed by the diocese in the early twenty-first century—the parish was consolidated with four other declining parishes, and all five reorganized as the new Resurrection Parish, which serves the Catholic community of downtown Jersey City. The 1888 church building on First Street is, as of this writing, under reconstruction. Although its original colorful stained-glass windows, dating from 1898 and crafted in Innsbruck, Austria, were removed some time ago, the church's basic historic façade is preserved, as it transitions into a multiunit luxury condominium complex for modern young urban professionals. Someday, they may find that the ghost of 1865 has followed. That might prove interesting.

This section was compiled from contemporary and modern accounts in numerous newspapers, including the Brooklyn Daily Eagle, Frank Leslie's Illustrated Newspaper, Jersey City Standard, Jersey Journal, New York Herald Tribune, New York Times *and* Trenton State Gazette. *For the full story of Mayor Cleveland's 1865 bounty scam, see James M. Madden's "Jersey City Politics and the Great Hoboken Bounty Jumper Sting of 1865" in editor Joseph G. Bilby's* New Jersey's Civil War Odyssey: An Anthology of Civil War Tales, from 1850 to 1961 *(Longstreet House, 2011).*

Hoboken's Forever Ship, 1841–1881

Following the Revolutionary War, Continental army colonel John Stevens purchased a large tract of land confiscated from Loyalists in Hoboken, establishing a connection between the Stevens family and that city that has endured to the present day. Stevens, born to a prominent New York family and raised in Elizabeth, New Jersey, was a King's College graduate. Politically active in promoting the adoption of the Constitution, Stevens turned his attention to business and engineering in the 1790s. He was involved in the development of early steam-powered vessels and designed the first American-built steam locomotive, which traveled at the then phenomenal speed of six miles per hour around his experimental track in Hoboken in 1825. In 1830, Stevens and his sons, Edwin and Robert, were founders of the Camden and Amboy Railroad, the first commercial railroad in the United States. The sons carried on the family business of transportation innovation after their father's death in 1838. In 1851, Edwin, along with another brother, Commodore John Cox Stevens of the New York Yacht Club, was involved in building the racing yacht *America*, which lent its name to the America's Cup race series.

In 1841, with the War of 1812 British naval blockade, coupled with continuing Canadian border disputes as background, Edwin Stevens decided to build a floating ironclad fortress equipped with formidable guns to protect New York Harbor in case of war. He then promoted

Edwin A. Stevens, father of the "Floating Battery." *James M. Madden.*

his concept of a revolutionary steam-powered 250-foot-long armor-plated shot- and shell-proof ship armed with heavy guns to the federal government. Stevens envisioned a highly maneuverable vessel powered by a nine-hundred-horsepower engine, with the ability to lower its hull to protect its screw propellers below the waterline. His arguments were good enough to convince Congress to pass the Stevens Battery Act in 1842, the first law of its kind, which provided funding to construct his wonder warship in Hoboken.

With the venture approved, Edwin and Robert Stevens began to carve a massive dry dock out of solid serpentine rock at their family estate on the Hoboken shoreline overlooking New York Harbor. The Floating Battery, as the vessel came to be called, would rise out of this dock, today the site of Sinatra Park. Digging proved difficult, and large pumps had to be installed to prevent flooding. The budget was set at $500,000, based on costs awarded for earlier vessels. Since the ship was an advanced and innovative design, however, no one really knew exactly how much it would cost or how long it would take to build, including the Stevens brothers. Over the course of several decades, they would find out.

In 1844, a significant gunnery advance invalidated much of the original Stevens design. Swedish inventor John Ericsson, who would later

The battery under construction in 1853. More than a decade along, little progress is visible. *James M. Madden.*

gain fame as the designer of the USS *Monitor*, developed a naval gun that could penetrate the ship's proposed four-and-a-half-inch iron plating. Ericsson's invention drove the Stevens brothers back to the drawing board in what would turn out to be a continual race to keep up with evolving technology. Soon afterward, the project suffered another major setback when Robert fell ill and went to Europe for several years to recuperate.

Although work on the Stevens project crept along, America displayed little interest in domestic ironclad warships, ceding naval innovation to Europe. The navy, no doubt coming to view the Stevens Battery as a bottomless money pit, eventually halted construction and announced that it would scrap the unfinished ship by 1851. Edwin, exercising family political influence and using French and British experiments with ironclads as his argument, got Congress to override the navy's decision and grant him the opportunity to radically redesign it with updated technology.

Stevens's newer design called for a much larger vessel, almost doubling the current unfinished craft in length to 440 feet, with a 53-foot beam and increasing the iron plating's thickness to six and three-quarters inches, able to withstand the most powerful artillery in service at the time. The new version of the ship also upped engine strength to 8,600 horsepower and speed from eighteen to twenty knots. Since these improvements

raised fuel consumption considerably, the coal bins were to be equipped with a high-powered ventilation system to ease the stokers' tasks. The bigger and better battery augmented its firepower as well, from six to ten guns, including five rifled cannons and five smoothbores. Gun crews would be protected by strengthened positions, their rates of fire would be increased by steam-powered ramrods and a water injection system would cool down overheating barrels.

Significant construction progress was made for a year and half until Robert Stevens's death in April 1856, after which all work halted until 1859. By this time, members of the Stevens family were dumping large amounts of their own money into the project—by one estimate, close to $500,000, a vast sum for the era. After dispensing the $500,000 authorized by Congress, with little to show for it after seventeen years, however, the navy lost interest once more. Slow construction progress, coupled with rapidly changing technology, doomed the Stevens Battery to obsolescence before it ever left its Hoboken dry dock.

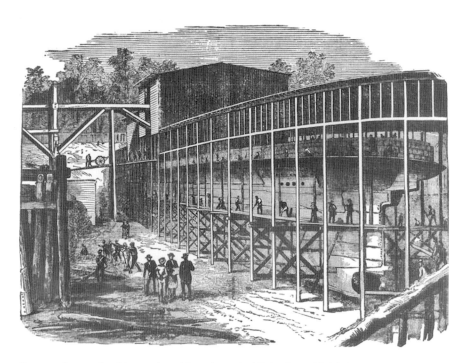

Construction on the ship continued into the early 1870s. *James M. Madden.*

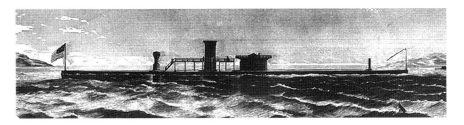

The last concept for the Stevens Battery, morphing it into an ironclad ram in 1874. It never made it to this stage. *James M. Madden.*

By 1861, it seemed that nothing could ever resurrect this overambitious dinosaur of a warship. Then came the Civil War, and with it yet another attempt to bring the Floating Battery to life. Edwin Stevens thought that an additional $700,000 investment could complete the project. He agreed to front the money himself, as long as the navy promised to accept his ship upon completion. The navy, unhappy with two decades of delays, decided to look elsewhere than Hoboken for effective new technical expertise and refused Stevens's offer.

Never one to give up, Stevens continued to push his cause, claiming that the Battery would take a major toll on Confederate ships and fortresses. To prove that his design principles worked, he purchased a small iron-hulled steamer and converted it into a warship, modifying it to provide speed, high maneuverability, a low profile and a large gun loaded below the deck by an armor-protected gun crew. Stevens hoped that this ship, accepted by the Revenue Cutter Service as the USS *Naugatuck* in late 1861, would be a success and reawaken interest in the battery. The navy borrowed the *Naugatuck*, and while in action in May 1862, its main gun burst, but armor protected the gun crew from the explosion as intended. Still leery of Stevens and his ideas, however, the navy returned the *Naugatuck* to the Revenue Cutter Service without endorsing it or showing any renewed interest in the battery.

In July 1862, Congress voted to turn all ownership of and rights to the Stevens Battery over to the Stevens family, and the unfinished ship spent the rest of the Civil War in its Hoboken home. Meanwhile, John Ericsson's USS *Monitor* battled the CSS *Virginia* in Hampton Roads. The era of ironclad naval combat had begun—without the Stevens family flagship.

Although the Confederate navy posed no real threat to New York Harbor, the defensive weakness of the port was a real concern for many officials in 1862. Hiram Barney, collector of the ports of New York, petitioned the navy to permanently station the ironclad monitor USS *Passaic* in the area to compensate for the lack of decent harbor defenses. The navy had different priorities, however, and wanted to get its new model ironclad ships, made in New York and New Jersey shipyards, into action as soon as possible, so the *Passaic* steamed south.

When the Confederate commerce raider CSS *Alabama* sailed along the northeast coast in 1862, capturing and burning merchant ships and causing panic in New York, there were calls for the Stevens Battery's resurrection from all quarters, as newspapers pointed out what they saw as glaring deficiencies of the New York Harbor forts and a lack of properly trained troops to man them. The panic passed, and the battery remained inert in Hoboken. And then the war ended.

In 1868, Edwin Stevens died and, in his will, left the battery, along with $1 million, to the State of New Jersey, with directions to complete what had become his life's work. Major General George B. McClellan, a New Jersey resident since his relief from command of the Army of the Potomac in 1862, had befriended Stevens when they had met in Paris many years before and was assigned as the project's chief engineer. McClellan temporarily moved to Hoboken and redesigned the ship one more time, converting it to an ironclad ram, and promised that the work would be completed in one year. Unsurprisingly, it wasn't. By 1874, with the money from Stevens's bequest expended, the vessel was still a long way from completion, but it had become an attraction for student engineers from the newly established Engineering Technical College located on the hill above.

New Jersey, stuck with ownership of an unwanted product, sued the Stevens estate, claiming that the landlocked ship was unable to perform as a warship, and therefore the state, as owner, should be able to sell it. The state won and sold the Stevens Battery for scrap in 1881—forty years after Edwin Stevens originally planned it as the next great new thing in naval history.

William Laimbeer paid a mere $55,000 for the battery and then hired two hundred men to disassemble it, at a cost of another $30,000.

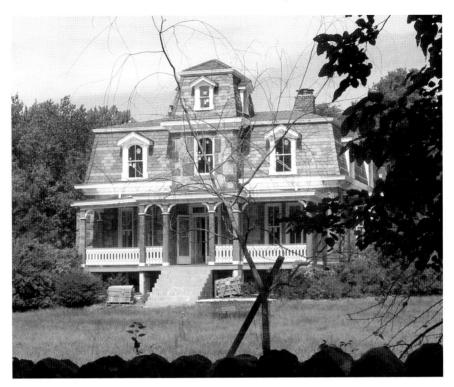

The Hilltop today, with the Stevens bell long gone. *James M. Madden.*

Ironically, the Floating Battery proved to have been so well constructed that Laimbeer's workers had problems destroying it, and his crews resorted to burning and exploding sections of the wooden hull. On several occasions during the process, firemen had to be called in to put out the resulting smoldering mess. One explosion sent large scrap metal shards flying for blocks throughout Hoboken, with shrapnel landing on sidewalks and damaging homes.

In the end, Laimbeer saw a return of $150,000 on his investment. Remnants of the once touted revolutionary ship ended up all over the world. Some parts were bought by large machine shops in Boston and other cities and put to a more mundane use than their original intent. Thousands of bolts were sold to a shipbuilder in Scotland, while others were purchased by a New York businessman who had them nickel plated and sold as souvenirs. Some salvaged steel was reportedly recycled into

shotgun barrels in England. Sections of the wooden hull that were not burned or blown up, still well preserved after forty years in dry dock, were used to build summer resort Queen Anne cottages in Babylon, Long Island. Sixteen engines were sold to coal mines in Pennsylvania, while the remainder of the propulsion plant, considered worthless, was broken up for scrap. Laimbeer took the four-foot (in circumference) bronze bell used to ring in the working hours at the Floating Battery shipyard as a personal souvenir. He installed the bell, dated "1841," in his father's country home, the Hilltop, which still stands on Hudson Avenue in Tenafly, New Jersey.

In February 1887, the *Trenton Evening Times* published a retrospective on this unique New Jersey saga entitled, "The Stevens Battery: How The Most Formidable of Ironclads Went to the Junk Shop." It was estimated that the Stevens family spent more than $2 million, in addition to the federal money allocated, for what was perhaps the biggest white elephant in American maritime history. In none of its three incarnations did the ship ever live up to its promise, and it was eclipsed by more modest and practical vessels that fulfilled naval needs. Despite that obvious history, several newspapers of the time lamented the fate of what had become, over the course of its life, seemingly the "Forever Ship," arguing that the government had been penny-wise and pound-foolish for not seeing the "opportunity to secure for a song" an ironclad that would have been, according to a journalist, the most formidable warship in the world. The navy, and history, thought otherwise.

This account is based on information from William Conant Church's The Life of John Ericsson *(Charles Scribner's Sons, 1911), George Iles's* Leading American Inventors *(Henry Holt & Company, 1912) and the following newspapers:* Trenton Evening Times, New York Times, Brooklyn Daily Eagle, New York Herald, New York Daily Graphic, Philadelphia Inquirer *and* Harper's Magazine.

Once Upon a Time in Newark

In the years immediately prior to the Civil War, Newark, New Jersey, was, as it had been before and has been since, in trouble. The city, which had made a promising start in the industrial age, was hit hard by the Panic of 1857, a fiscal crisis with its roots in a deflation in western land values purchased by overmortgaged railroads. The final blow to the American economy was administered by the fraud-fueled crash of a huge insurance company doubling as a bank. As the country's financial markets reeled, the bottom fell out of the city's economy. Newark lost one-third of its population as workers wandered off elsewhere in desperate search of a way to earn a living. And then, in 1861, the war came. At first, it threatened to finish the job that the speculators and crooked bankers had begun, as the Southern plantation slave outlet for the city's cheap clothing and shoes disappeared in a cloud of gunsmoke over Charleston Harbor.

As the war wore on, however, and New Jersey's men marched off to fight in it, the state and federal governments turned to can-do cities like Newark to provide soldiers' uniforms, along with vast quantities of leather goods, including shoes, belts, cartridge boxes and harnesses, while cutlers like Henry Sauerbier turned out sabers and swords. As the conflict ended, the city seemed to be hitting its industrial stride once more—this time bigger and better than ever. The boom continued in the immediate

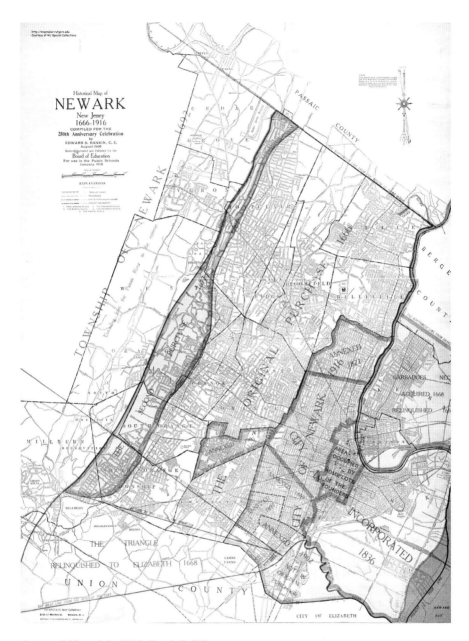

A map of Newark in 1872. *Joseph G. Bilby.*

postwar years. By 1870, Newark was bustling with smoky factories—seen then as a sign of prosperity, not pollution—and new construction of blue-collar housing within walking distance of those factories, along with landmark homes for the wealthy along tony High Street. Newark was, its city fathers thought, truly on a forever fling into a boundless future.

In 1872, when the city's population reached 115,000 souls, Newark decided to celebrate its growing importance on the national scene by following an example set by manufacturing cities in England but never seen on these shores: a grand industrial exposition. The city's business leaders planned an extravaganza that would finally gain the grand old town on the Passaic River the honor it deserved. They were understandably miffed by the fact that, although Newark could and did manufacture almost anything, as well as the machine tools needed to manufacture almost anything, many viewed the city as simply a "suburb of New York." To make matters worse, some of Newark's factories were stamping their goods "made in New York" in order to capitalize on their proximity to the best-known city in the United States. Industrial flimflam of this sort had gone on to a greater or lesser degree for many years, however. The revolvers of "Manhattan Firearms," a major handgun maker of the Civil War era, were actually manufactured at the corner of Orange and High Streets in Newark. Oh sure, you could look at the fine print address stamped on the barrel and see "Newark," but the company was certainly not bragging on its Jersey location. The shadow of Manhattan, a mere nine miles away across rivers and meadowlands, has always loomed large over Newark and its people.

The exposition, the first of its kind in the United States, would solve much of that identity problem, some of the city's leading citizens believed, and thus enable Newark to claim its rightful place in the American industrial sun. To be sure, not everyone felt that way. Some, *Newark City Directory* editor Arthur M. Holbrook recalled, "ridiculed the idea, called it quixotic and said it had better not be attempted." Holbrook himself actively pushed the idea of the exhibition with the members of the city's board of trade and convinced them that it was not only desirable but also feasible. Once Newark's manufacturers decided to sponsor what was shaping up to be the show of the century, they had to figure out

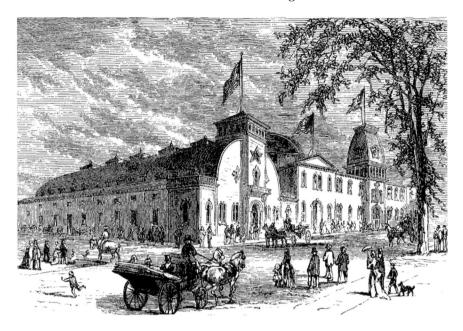

"The Rink" as it looked during the 1872 exhibition. *James M. Madden.*

where to hold it. There was quick consensus that only one building fit the bill: the thirty-five-thousand-square-foot roller-skating rink located on Washington and Court Streets. Preparations were soon underway, and as enthusiasm began to mount, it appeared that even this venue would not be big enough, so "the Rink" was expanded by additions to cover fifty thousand square feet of space.

Despite intense summer heat, with temperatures in the nineties, the Newark Industrial Exhibition opened to the public on the evening of August 20, 1872. Crowds were guided to the Rink by a bright calcium light beacon and the snappy music of Reinhard's brass band, and between three and four thousand people made their way to the festivities. In a bipartisan love fest, former Republican governor Marcus Ward—a local merchant who had made a fortune in the candle business and a philanthropist known as "the soldier's friend" during the late hostilities—praised "that great body of skillful mechanics and artisans with which our city abounds." Former Democratic mayor and National Guard general Theodore Runyon boasted that Newark's factories employed "over 30,000 hands" at wages averaging

$500 per year. The *Newark Daily Advertiser* characterized the exhibition's opening as "a proud night for our mechanics," with the products of their labor on display for all to see.

The Rink's entranceway featured a stunning flower-draped marble fountain with goldfish swimming in it, past which visitors entered a gas-lit hall decorated with mirrors and bedecked with European and American flags. And those visitors ran the class gamut, with elegantly dressed ladies rubbing elbows with common working stiffs, all in solidarity with the view that the exhibition was a tribute to all the people of the city. The *New York Times'* report of the affair provided a list of all the goods made in Newark

Harper's Weekly portrayed the international exhibit sponsored by the YMCA and held inside the Rink building during the 1874 Newark festival. *James M. Madden.*

on display: clothing, machinery (including a massive fifty-horsepower engine), lamps, jewelry, oilcloth, pottery, paint and varnish, books, buttons and even a trunk that was convertible "by a very simple process, into a baby's cradle and bath-tub." There were models of larger Newark products, like ships. The city's artists were not neglected either, and their statuary and paintings filled a separate gallery. Holbrook had triumphed over the naysayers, and he was rewarded himself by the show's managers with a top-quality Newark-made watch and chain, while Mrs. Holbrook took home a bagful of Newark-made jewelry.

A traffic jam in Newark during the 1872 exhibition, as portrayed in *Harper's Weekly*. *James M. Madden.*

The Newark Industrial Exhibition ran for fifty-five days, with extensive press coverage, before closing to the strains of Reinhard's band on October 11. Daily admission was thirty cents, while those who could not get enough of the show could spring for a three-dollar season ticket. Newark became the place to be in the New York metropolitan area, as the exhibition attracted an estimated 130,000 people during its run, including presidential candidates Horace Greeley and Ulysses S. Grant. "Newark has done well," said Grant, on his way to a second term.

In the aftermath, there seemed to be no stopping Newark, and the *New York Times* opined that "no city in the country of any size [has] a brighter future." Sadly, it was not to last. The fiscal roller coaster ride created by the Panic of 1873, yet another American economic disaster with its origins in railroad speculation and financial institution skullduggery, led to a painfully slow recovery that stretched out to almost a decade. Although the city, intent on maintaining the boost it had received from the initial celebration, mounted smaller shows over the next three years, the Panic of 1873 put the brakes on Newark's ride.

Some optimism remained, however. In 1874, the YMCA overshadowed an industrial show by staging the "Bazaar of All Nations" in and around the Rink. The Bazaar, which featured "one of the most novel and attractive exhibitions which has ever been offered to the public," was internationally, rather than locally, focused. Using the hall as an anchor, the promoters built "in front and rear, 'mock-up' representations of the houses of different nationalities, including Chinese, Syrian, Italian, Swiss, Russian, German, Turkish, Venetian, French, English, Swedish, Scottish and others, showing their actual appearance in color, shape, size and mode of construction." In a stroke of supreme irony, the wares for sale were largely those imported from the countries represented, not those crafted in Newark. A special preview for the press featured a free "Arab" meal of "rice, mutton and other delicacies" preceded by an "Arabic prayer" and served by "five female slaves" in a tent erected in a nearby park. Although invited, the president didn't make it this time, sending, as did New Jersey governor Joel Parker, a "letter of regret" to the organizers, although Vice President Henry Wilson did grace the opening ceremonies on May 7.

The *New York Daily Graphic* view of the "Bazaar of All Nations" held in Newark in 1874. *James M. Madden.*

The 1876 Centennial Exhibition in Philadelphia gave Newarkers an excuse to cancel that year's planned event with the excuse that the city's merchants and manufacturers had to devote their time, attention and funds to representing themselves in Philadelphia. There would be no more massive "made in Newark" shows. Almost a decade had passed when, in 1882, Arthur M. Holbrook reprinted the original 1872 program in the hopes of reinvigorating the exhibition, but to no avail. In his introduction, Holbrook plaintively asked, "Is it not possible to again astonish the world by an exhibition of such magnitude as to keep the city of Newark prominently before it as the 'Birmingham of America?'" Apparently, it was not.

Newark would remain a substantial industrial center well into the twentieth century. There would be other, albeit far smaller, industrial, art and craft expositions in the city, sponsored by the Newark Museum and Library, and although enthusiasm never equaled those heady days in the summer of 1872, signs of the optimism and boosterism that generated the first great exhibition would surface, time and again, as Newark reinvented itself over the generations. The city is sometimes up and sometimes down. Even today, as it swings through yet another down period, it would be folly to underestimate it.

There are a number of good histories of Newark. We particularly like two: John C. Cunningham's Newark *(New Jersey Historical Society, 1966) and Brad R. Tuttle's* How Newark Became Newark: The Rise, Fall and Rebirth of an American City *(New Brunswick, 2009).*

Turmoil in Trenton

Post–Civil War New Jersey was a society in rapid transition. As Thomas Fleming pointed out, "the [state's] population soared from 906,096 in 1870 to 1,883,669 in 1900. Manufacturing soared as well, with factories increasing by 230 percent." Much of the increase was from a tide of new immigration, with the already entrenched Irish supplemented by southern and eastern European Catholics and Jews.

New Jersey became the scene of a series of notable political struggles, as the state's parties attempted to cope with a rapidly evolving demography teetering atop an unpredictable economic seesaw. The Republicans, harking back to their partial "Know-Nothing" anti-immigrant origins, became the political choice of New Jersey's native-born Protestants; the Democrats, although initially split between immigrant Catholics and old-line Protestants, morphed into the political champions of the immigrant masses. Several prominent native-born Protestant Democrats, most notably two-time governor Leon Abbett of Jersey City, eventually allied themselves with the urban immigrants. Republicans fought back in many ways, in one case taking over the government of Jersey City and in another attempting to repress the vote by ordering election day polls in urban areas to close before immigrants got off work for the day.

In addition to, and complicating, the cultural and religious conflicts playing themselves out in late nineteenth-century New Jersey political life,

large corporations invested a good deal of time and money in making sure that their voices were heard before those of their competitors—or those of the taxpayers. Railroads had always had a disproportionate amount of political influence in New Jersey, since the nation's first real railroad line, the Camden and Amboy Rail Road and Transportation Company, merged with the Delaware and Raritan Canal as the "Joint Companies" in 1830. The Joint Companies soon secured a transportation monopoly from compliant legislators in Trenton. The monopoly granted them exclusive rights to transport people and goods across the state between New York and Philadelphia by rail or canalboat. In return, the company promised to pay the state for the privilege, allowing legislators to fund the government without raising money through taxes—and also ride the rails themselves for no charge.

Although modified a bit over the years, the Camden and Amboy agreement survived in the face of mounting criticism regarding travel safety, tax evasion and cheating on the money it was supposed to pay to the state through 1873, when the monopoly was finally legislatively broken after the railroad's owners leased it to the Pennsylvania Railroad for 999 years. The owners of the Pennsylvania Railroad, however, had their own legislative game, as did their rivals—and they all played it well. Thanks to legislative fiat, local governments across the state were forbidden to tax railroad property at full value. Legislative fights were frequent, many of them between assemblymen and senators actually in the employ of the railroads—Democratic state senator Daniel C. Chase of Middlesex County, for example, worked at the Pennsylvania Railroad's South Amboy station.

In one striking example, the campaign for governor in 1880 between Democrat George C. Ludlow of Middlesex County and Republican Frederick A. Potts of Hunterdon County could easily have been characterized as a contest between the then two most influential railroads in the state, as Ludlow was an attorney for the Pennsylvania Railroad and Potts a major stockholder in the Jersey Central Railroad. Ludlow won by a mere 651 votes out of 250,000 ballots cast in the closest gubernatorial race in state history, amid rumors that the Pennsylvania executives had ordered their employees to vote for him.

In 1882, a majority of New Jersey assemblymen and state senators allied with the Jersey Central management pushed through legislation in Trenton allowing the corporation to increase its capital stock without approval of the current stockholders, in essence undercutting the percentage ownership of the railroad by those stockholders. Ludlow, a Pennsylvania Railroad man, vetoed the measure, calling it "immoral," but both houses overrode his veto with substantial majorities.

The average New Jersey voter of the era found the Pennsylvania Railroad's 1870s land grab in Jersey City more obnoxious than the Jersey Central stockholder scam. The legislature had allowed the railroad to actually create new land in Jersey City by extending the existing waterfront into the Hudson River. This additional real estate was created by transporting New York City trash across the Hudson River to Jersey City and dumping it as landfill in Harsimus and Communipaw Coves. When the wind blew inland, the whole city reeked of decomposing garbage. To add insult to injury, the Pennsylvania Railroad refused to allow Jersey City to build any roadways across the new land, which was taxed far below the rates Jersey City small businesses and homeowners paid.

Sometimes, legislative squabbling erupted in actual violence. In 1887, a struggle between partisans of both parties (including some who had switched sides to air personal intraparty grievances) over who to elect to the United States Senate (senators were then elected by state legislatures, not popular vote) led to "fist shaking...ribald language" and an actual physical struggle over the assembly speaker's gavel.

By the 1890s, railroads were not the only business players buying or renting the services of Garden State politicians. Along with liquor dealers, who became political players to counter a growing movement for national prohibition of sales of their product, New Jersey's racetracks were also forced into a defensive mode. As opposition to gambling—seen, along with alcohol consumption, as an immigrant vice—grew among the Protestant middle-class Republican voters living outside the urban corridor of the state's northeast, the racetrack owners took a page from the railroaders' book (the liquor dealers had already hired Leon Abbett as their principal attorney between his terms as governor) and put legislators on the payroll. Democratic

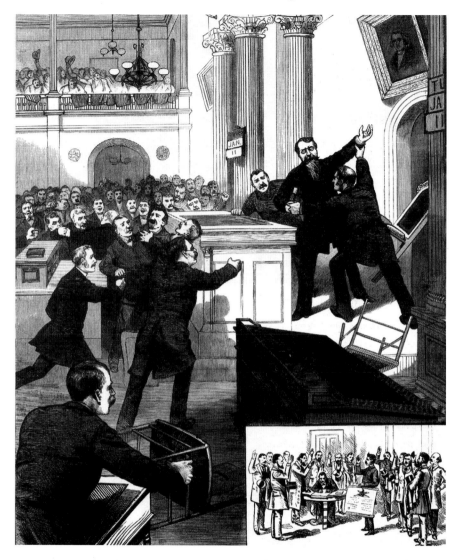

A brawl in the New Jersey Assembly in 1887. *James M. Madden.*

assembly speaker Thomas Flynn, for example, was paid to be the "starter" at Billy Thompson's Gloucester track, although how he could accomplish that task while living at the other end of the state in Passaic went unsaid. Other legislators were on the payroll books at the tracks at Long Branch and Guttenberg. Lawmakers were also, of course, granted free admission to the tracks and, no doubt, some topical tout tips for their efforts.

Due to the increasing power of the racetrack owners, by the early 1890s New Jersey's legislative governing bodies were collectively referred to derisively as "the jockey legislature" by the media of the day. In response, Speaker Flynn dismissed the racetrack opposition as composed of "old women and dominies [clergymen]." Actually, the opposition to racetrack gambling was deeper and far more widespread, even among Catholics, as immigrant women were not enthralled with their husbands dropping a paycheck on the ponies. To the speaker's surprise, as many as five thousand of those folks showed up in Trenton one day—mostly Protestants, but with a few Catholic priests in attendance—and took over the legislative chambers in a previously unheard-of protest demonstration. In the election of 1893, enough members of the racetrack caucus were thrown out of office to allow legislation banning gambling to triumph. It passed the state senate by one vote—cast by James Bradley, the founder of Asbury Park, who was serving his one and only term as a lawmaker. Although Bradley cited his evangelical religious convictions as the reason for his vote, disgruntled Long Branch residents were sure that his desire to crush resort town competition was at the root of it. Horse race gambling would not return to the state until 1940.

With the dawn of the twentieth century, the idea of reform took hold in both parties, and the rise of Theodore Roosevelt to the office of president signaled a different direction in politics. There would be corruption, of course, as it is often the handmaiden of politics, but it would take different, more subtle courses; ironically, in some cases, the people of the state would actually gain some benefit from it as well. Garden State politics have always been interesting but never uncomplicated.

Thomas Fleming's survey history of the state, New Jersey: A History *(W.W. Norton, 1977), provides an excellent summary of the post–Civil War ethnic political struggles in New Jersey. Richard A. Hogarty's* Leon Abbett's New Jersey: The Emergence of the Modern Governor *(American Philosophical Society, 2001) is an excellent detail study of the era. William Edgar Sackett's* Modern Battles of Trenton *(John L. Murphy, 1895) is a colorful period work by a journalist who witnessed the events, if a bit overwritten and overdramatized in the journalistic style of the era.*

Jersey City Gets "Ripped"

Due largely to its burgeoning immigrant population, Jersey City became the epicenter of New Jersey's post–Civil War political struggles, reflecting the wider contests between native-born and immigrant, urban and rural, Democrat and Republican and Catholic and Protestant visions of the state's future. The scenario played out against a bizarre, authoritarian and (one could even say) dictatorial statute voiding the decisions of the city's voters, which turned an act of political vengeance into one of political downfall for the perpetrators.

Native-born New Jersey Protestants, mostly Republicans, fearful of what they perceived as a Catholic immigrant tide overwhelming them, fought back legislatively in a number of ways, including attempts to suppress immigrant voting and gerrymandering election districts to favor the native-born. In addition, they proposed specific legislation in Trenton barring Catholic clergymen from tending to the religious needs of Catholics in prisons and reformatories, banning state fiscal assistance to Catholic schools and attempting to prohibit the establishment of Catholic schools altogether.

This ongoing conflict, which had its roots in the famine surge of Irish immigration of the 1850s, came to a head in Jersey City, where, by 1870, Irish immigrant voters, virtually all of them Democrats, made up a significant portion of the city's electorate. Germans, the other significant

immigrant community, albeit nowhere near the strength of the Irish, and with a significant Protestant element among them, reacted to the Celtic influence by tending to become Republicans. As the Irish representation in city government increased, so did their influence on the city's politics and culture; saloons remained open on Sunday, and police tended to support striking Irish railroad workers, to the horror of the business-oriented native-born Republicans. There was greed involved in the resentment as well, and one account recalls that "speculating Republican contractors had set their eyes upon…the treasury" and were prepared to grab it by any means possible.

In 1871, local Republicans, who saw their influence in the city eroding at an increasing rate, with no hope of gaining electoral victory even through gerrymandering, demanded that the Republican-dominated New Jersey legislature impose "charter reform" on Jersey City, which they portrayed as hopelessly corrupt under Democratic rule. The "reform"

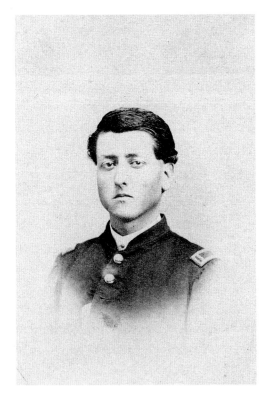

"The Defaulter," Alexander Hamilton, as a young lieutenant during the Civil War. *New Jersey State Archives.*

proposed would place Republican appointees in charge of commissions that would control much of the city's administration, including the police, public works, fire and finance departments.

While Jersey City's board of alderman, the city's elected governing body, would remain in office under the proposed legislation, it would be stripped of virtually all power "except that possibly of granting licenses to saloon-keepers." The legislature accommodated the request, passing the legislation over the veto of Democratic governor Theodore Randolph. Bypassing the governor was a relatively easy matter, since the state constitution adopted in 1844 legislatively tilted power to rural regions and small towns and, in addition, only required simple majorities in the assembly and senate to override a gubernatorial veto. And so the takeover bill, promulgated as "special legislation" but known popularly as "ripper legislation," as it ripped control from the hands of local officials, went into effect. To be fair, it should be noted that the Democrats, who temporarily dominated the legislature in 1870, had then initiated similar laws interfering in Republican municipal governments, but to nowhere near the extent of the proposed Jersey City legislation.

Once appointed, the Jersey City commissions acted quickly to undermine Irish immigrant influence. The size of the city police department was increased significantly by adding new, native-born Republican recruits, diluting the Democratic majority, while at the same time firing or demoting a number of Irishmen, including the chief, who were already on the force. The commissioners moved to shut Irish Democrats out of all government jobs and contracts they could. The new police commissioner told a reporter that no more Irishmen would be hired for the force and that only native-born Americans and Germans should apply for future employment. In an attempt to impose small-town morality in addition to raising money for the treasury, the new regime immediately upped the fine for public drunkenness from two dollars to five dollars, without a clear definition of the parameters of the offense.

There is evidence that some native-born Democrats, including former mayor Orestes Cleveland, who had lost the city an immense amount of money during the Civil War in a recruiting scam, actually assisted, or at least quietly cheered on, the Republicans. These Democrats hoped to

regain control of their own party from the immigrants, and the implosion of Irish political power through gerrymandered districts and the "ripper" law enabled them to do so. In their own turn, however, unsupported by Irish votes, now mostly gerrymandered into a single horseshoe-shaped district to limit their citywide influence, the native-born Democrats were smashed by the now ascendant Republican machine.

With their takeover complete, the Jersey City Republicans proceeded to hike local taxes and issue bonds, using the money raised to extend sweetheart contracts to themselves and their friends. A reporter concluded that "money was squandered right and left" and at such a great rate that even Republican newspapers from Newark and Trenton commented unfavorably on the growing evidence of fiscal irregularities. Democratic governor Joel Parker issued a special message pleading for legislation to cancel the takeover. The members of the "Ring" running Jersey City exerted every political subterfuge they could to keep their personal cash registers ringing, however, and did so successfully for a time.

Overreach and overconfidence would, however, eventually lead to a change of fortune for the "rippers." John Rhinehardt, a French-born Democrat with a German-sounding last name, swept to victory as Hudson County sheriff with Irish support and empanelled a grand jury in January 1872. In succeeding months, Rhinehardt's panel handed down a blizzard of indictments against Republicans, including the state-appointed police commissioner, who was allegedly jailing and fining people for trivial offenses. Most of the early indictments were eventually dismissed, but Rhinehardt began to strike pay dirt when an investigation led to the trial and conviction of Republican Public Works commission member William Bumstead on corruption and bid rigging charges, and police officials were exposed for forcing political contributions on their employees. As the economy of the city, state and country plunged into a downward spiral following the Panic of 1873, and the city approached bankruptcy in its wake, the drumbeat of indictments continued.

The kiss of death for the state-appointed officials, as well as the whole concept of legislative preemption of municipal government, was the case of Alexander D. Hamilton. Hamilton, who had served as a first lieutenant in the Second New Jersey Cavalry during the Civil War, was

The woman, actress Winetta Montague. *James M. Madden.*

appointed, due to family and political connections through the "Pavonia Club," as Jersey City assistant treasurer at the time of the state takeover. When the treasurer refused to issue unnecessary and illegal bonds and was fired, the compliant Hamilton was promoted to take his place. In 1873, the twenty-nine-year-old official, "a low-lived fellow, given to evil associations," abandoned his wife and children and absconded with the treasury and his paramour, the "tall and well developed" New York City actress Winetta Montague, whom he had apparently met while she was performing in Jersey City and on the outs with her second husband. While newspaper reports had Hamilton, "the defaulter," fleeing to various localities, including Connecticut and Boston, in the immediate aftermath of his transgression, Jersey City police inspector Benjamin F. Murphy, perhaps doubly inspired to track the crooked treasurer down

due to his own Irish heritage, was assigned to the case. Murphy thought that the trail led in a southern direction. He was right.

Murphy found Montague in Philadelphia, and she advised that the delinquent treasurer was on the road to Mexico. After a series of adventures, Hamilton ended up in Corpus Christi, Texas, where Police Chief Thomas Parker extorted $7,500 of Jersey City money out of him before handing the treasurer over to "Pedro the Mexican," who escorted Hamilton across the border and into the custody of a gentleman known only as "Happy Jack," who then turned him over to local powerbroker and occasional bandit Juan Cortina.

Word of Hamilton's whereabouts got back to Jersey City, and Inspector Murphy was soon on the way to the Texas border. After an interview in Mexico with Cortina, who, surrounded by gun-toting associates, claimed that he had never heard of Hamilton (who was in the next room listening in), the Jersey City gumshoe returned home empty-handed. The Grant administration attempted and failed to get Hamilton extradited from bandit country, and there was word that the errant treasurer was on his way to found a new nation somewhere in Latin America and perhaps install Montague as queen. Several months later, however, there was a knock on Murphy's front door, and the inspector opened it to a ragged Alexander D. Hamilton, who claimed that the Mexican bandits had stolen all of the city money he had absconded with and then put him on a boat to Brazil.

Hamilton pled guilty and was given a surprisingly light sentence of three years in the state penitentiary and a $1,000 fine for his malfeasance. His crime, however, hastened the end of Republican rule in Jersey City and with it the ability of the New Jersey legislature to enact "special legislation." In 1875, voters passed an amendment to the state constitution, ending the practice of arbitrary legislative intervention in the affairs of municipalities through appointed commissions. There would be much more political conflict down the road, and the bitterness of Jersey City's Irish community at the imposed "ripper" government endured for generations. In the end, it could be argued that the most significant outcome of the Jersey City takeover, aside from Alexander D. Hamilton's bizarre adventure, would be, contrary to the intentions

of its originators, the strengthening of the immigrant vote in statewide elections and the eventual rise of Democratic political boss Frank Hague. Born in the gerrymandered "horseshoe" three years after Hamilton took off with the treasury, Hague set out to build a political machine on residual immigrant anger.

Thomas Fleming's New Jersey: A History *provides a good overview of the Jersey City story. For a more detailed period look at it, see Sackett's* Modern Battles of Trenton. *The saga of Alexander Hamilton is well told in Marc Mappen's* Jerseyana, the Underside of New Jersey History *(Rutgers University Press, 1992).*

Trouble on Garret Mountain

Although such an outcome seemed highly unlikely, what began as an annual spring festival near Paterson, New Jersey, in 1880 ended in a shooting and the greatest local riot that anyone then alive could remember.

The day began peacefully enough. Paterson's German Americans had followed an ancient Teutonic tradition of ascending a mountain on the first Sunday in May to celebrate the change of seasons for close to thirty years. The ritual began well before dawn, when independent singing societies, accompanied by brass and string bands, wended their way along moonlit wooded pathways up Garret Mountain, the highest peak in the area, where they gathered in an area known as "Colt's Point" to greet the sunrise. They were followed by a massive procession that culminated with daylong celebrations on the mountainside.

As the years rolled by, many of the Paterson's non-German population began to tag along in search of weekend relief from their hectic industrial jobs in the growing city or for simple entertainment. After their ascent, revelers would wait for the predawn mist to burn away with the sunrise, revealing a panoramic view of their city below and the surrounding countryside, much of it still rural, rolling out toward New York City and northern New Jersey beyond.

Unfortunately, not all the hangers-on were interested in nature walks, sun worship and landscape gawking, and the event began to attract a

German immigrants gather to greet the dawn atop Garret Mountain overlooking Paterson in 1880. *Frank Leslie's Illustrated Newspaper/James M. Madden.*

younger, rougher crowd that looked forward to a day of intoxication and mischief-making. Rather than confine themselves to narrow pathways, many of the city day-trippers took cross-country shortcuts, dismantling fences and trampling crops. One such property, which included a simple frame house, barn and sixty acres of farmland, was abandoned by a tenant after one year's onslaught. The property owner had difficulty either selling or renting the farm because of its proximity to the annual line of march and offered to lease at a greatly reduced price. There were no takers until William Dalzell came along.

Dalzell, born in County Down in northern Ireland, owned a grocery and liquor store in Paterson and rented the farm with the intent of growing potatoes, cabbage and carrots for sale, as well as raising animals. The entrepreneurial grocer, nicknamed "Devilish Dalzell," had a reputation in town for his quick temper and was labeled by one resident as an "out and out crank." When an inebriated shopper tossed some potatoes at him, Dalzell responded by hitting the man in the head with a five-pound weight and then, after the drunk dropped unconscious to the floor, slashing him with a knife. On another occasion, a disgruntled customer returned to the market with a handgun, and Dalzell immediately pulled

his own revolver. The potential gunfight was broken up by police, but the grocer's reputation as no one to trifle with was enhanced.

As revelers began to trudge down Garret Mountain that May morning, one party, seeking an easier route home, took what had become a time-honored detour across Dalzell's rented property, tearing down the fences and stampeding across his recently planted crops. Noting the downed fencing, more people began to pour through the gap. Dalzell's son, Robert, challenged the intruders, led by John J. Van Houten, and was roughed up in response. As this point, Dalzell appeared on the porch armed with a double-barreled shotgun, intending to scare off the trespassers, who responded by heckling him. Unsurprisingly, considering his reputation, Dalzell lost his temper and charged off the porch toward the crowd, gun in hand.

What happened next is unclear. Two accounts eventually emerged. In one version, Dalzell dropped the shotgun, and it went off accidentally, and in the other he deliberately fired it. No one argued the outcome: Van Houten, hit in the stomach by the charge, was dead before he hit the ground. The deceased was a popular local figure, a newlywed and the stepson of a Paterson alderman, and his enraged friends surged toward Dalzell. One halted to place a coat over Van Houten's body, while the rest pursued the Dalzells, who were now in rapid retreat.

The Dalzells fled to the barn, which was immediately surrounded by a mob pelting it with stones and bricks. In response, the belligerent grocer appeared at a window and fired his shotgun indiscriminately, wounding a small girl and several other innocent bystanders, which angered the crowd even more. Some citizens, complaining that recent Paterson murderers had gone unpunished, said that it would not happen this time and tied a length of rope into a noose and suspended it from a nearby tree. Eventually, someone had the idea to torch the barn to smoke out Dalzell. As the building went up in flames, he and his son fled in a mad dash for the house, evading their pursuers. The building burned to the ground, however, killing many of his animals.

As the battle raged on, word spread downhill to Paterson, where the police force, advised that as many as ten thousand angry people were swarming around Garret Mountain, faced a conundrum; the sheer

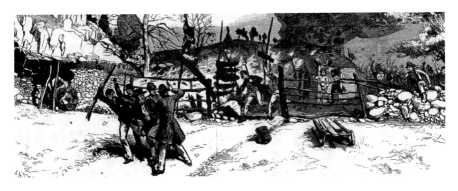

The police rescue Dalzell from the burning house. Shortly afterward, they managed to get him into a coach that brought him to Newark. Harper's Weekly/*James M. Madden.*

numbers involved gave the lawmen pause. Special constables were sworn in as reinforcements, and the Passaic County sheriff called on the Paterson Light Guard, an "independent military and social organization" then forming under Joseph W. Congdon. Congdon declined the request for assistance, stating that it would be illegal as the unit was not officially part of the state's National Guard; since it was still recruiting, it was also untrained and did not even have ammunition for its rifles. Although some suggested that the Guardsmen were reluctant to assist the police because they had friends among the rioters and believed that Dalzell should get what he deserved, New Jersey adjutant general William Stryker subsequently corroborated Congdon's contention that there was no legal basis for the Light Guard to assist authorities. Stryker did note that individual members could enlist as part of a sheriff's posse. A telegraphed plea to Governor George B. McClellan's office resulted in a standby order to the New Jersey National Guard's Fourth Regiment in Jersey City should the riot worsen.

Meanwhile, the siege of the Dalzell farmhouse continued. It was hit by a barrage of stones and bricks, which broke all the windows. Dalzell occasionally fired his shotgun at the crowd, inflicting minor wounds on his besiegers and driving them back when they got too close. And then they set fire to the house, just as Paterson's mayor, the Passaic County sheriff and a number of police officers arrived at the scene. The mayor and sheriff tried to distract the mob with speeches, appealing for restraint. While they spoke, several officers, under the cover of dense smoke from

the burning house, reached the Dalzells and tried to move them to a neighboring house. The mob noticed and took off in hot pursuit, intent on grabbing the grocer for a public lynching. They actually got their hands on the senior Dalzell, but the lawmen counterattacked, recaptured him and headed in the general direction of Paterson.

The officers got a bit of a head start when the crowd mistook an innocent bystander for their quarry and beat him unmercifully before his true identity was discovered. And then Reverend William McNulty appeared on the scene, summoned by an Irish policeman who thought that the priest might talk some sense into the mob. McNulty, pastor of St John's Roman Catholic Church in Paterson, implored the crowd to consider Christian charity, which did not condone lynching, in their actions. His moral authority provided a brief pause—and enough time for the police to push Dalzell into a waiting coach. As the rioters realized what was happening, they began to throw stones at the coach, and Father McNulty climbed atop it, pleading for them to stop. The coach took off at top speed, with the priest hanging on for dear life as it bounced down the road. Some rioters tried to climb on but were clubbed off with

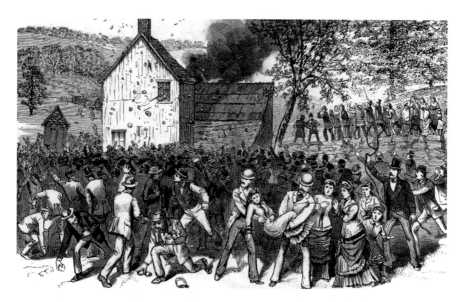

Dalzell fired at the people in the crowd occasionally as they pelted the barn, and then the house, with rocks and bricks. Frank Leslie's Illustrated Newspaper/*James M. Madden*.

police nightsticks. In a moment of supreme irony, Dalzell, a committed Protestant "Orangeman," was saved by a cleric of a church of which he was a sworn enemy.

Down the road a bit, the Dalzells were switched to another coach, while the first one rode on as a decoy. The first coach, minus the Dalzells, McNulty and the police, was eventually tracked down and destroyed by frustrated pursuers. Dalzell and his son were spirited away to the Newark jail for safety, and the Essex County sheriff issued strict orders that no one was to even approach the prisoners. In the meantime, enraged rioters spread out across Passaic County, visiting local jails and looking in vain for the gun-toting grocer. Indictments were eventually handed down on Dalzell, as well as many of the rioters, and he was eventually returned from Newark to Paterson, where the 1880 census lists him as a tenant of the county jail that July.

In custody and charged with manslaughter, William Dalzell hired a first-rate legal team, including Republican party political heavy hitters and law partners John W. Griggs and Socrates Tuttle. Griggs later served as New Jersey governor (1896–98), leaving that post to serve as United States Attorney General in the McKinley administration. Tuttle, a former Paterson mayor who was lead counsel for the defense, later became a law partner and father-in-law of Garret Augustus Hobart, former New Jersey Assembly Speaker and state senate president who would become McKinley's first vice president.

Dalzell entered a plea of not guilty after Tuttle visited him in jail and advised him to keep his mouth shut for once. The attorney argued successfully that due to the intense local feeling in the case, a change of venue was in order, and the trial was moved to neighboring Bergen County, where the local farmers, according to a reporter, were known to "hang a man for stealing a cherry" and viewed trespassing as a high crime. As Tuttle had surmised, Bergen County jurors, viewing his actions as a legitimate defense of his property, acquitted Dalzell, and he returned to tending his store, apparently somewhat more subdued than in his previous tenure. (He did file a claim for $651 in damages against the city, however.) Several cases brought against the trespassers also fell apart, in a welter of confusing testimony and reluctant witnesses.

The year after the riot, the crowds of sun worshipers swarming up and down Garret Mountain were greatly diminished, apparently in fear of renewed violence. Dalzell's rented property still lay in ruins, although the broken fence, which had initiated the fatal chain of events of the previous year, had been repaired. Large "No Trespassing" signs were posted along the property line. But the Dalzells, father and son, were nowhere to be seen.

"Devilish Dalzell" died in Paterson in 1920 at the age of ninety-two.

This section was gleaned from William Nelson and Charles Shriner's History of Paterson and Its Environ (The Silk City) *(Lewis Historical Publishing Company, 1920) and from the following period newspapers:* Frank Leslie's Illustrated Newspaper, Harper's Weekly, New York Daily Graphic, New York Evening Post, New York Herald, New York Sun, New York Tribune, Trenton State Gazette *and the* National Police Gazette.

Asbury's Inferno

The headlines emblazoned across page one of the April 6, 1917 edition of the *Asbury Park Press* told of America's entry into the global conflict that had consumed the Old World for almost three years: "War Declaration Signed by President." Yet even that momentous news was overshadowed by a bigger local headline that captured the attention of anyone who lived in the New Jersey shore area: "Greatest Fire in City's History Sweeps Four Blocks."

Indeed, the raging inferno that had torn through the heart of Asbury Park the night before was one of the greatest catastrophes to plague the renowned shore resort. The devastating blaze struck during the Easter season, when throngs of tourists were enjoying a vacation stay at the bustling city by the sea. It was a disaster that struck a tremendous economic blow in Asbury Park, by then a long-established resort that regularly drew thousands of visitors to its wide boardwalk, sandy beaches and plush hotels.

On the night of Holy Thursday, many of those visitors were enjoying a pre-Easter outing on the boardwalk, despite the rain and heavy winds gusting in from the ocean. In the cavernous casino, a large crowd had gathered for a "patriotic entertainment," while a dozen hardy bathers cavorted at the Natatorium, a two-story Greco-Roman pavilion with a heated indoor saltwater swimming pool. It was here that the infamous fire, sparked by defective wiring, began at about 9:30 p.m.

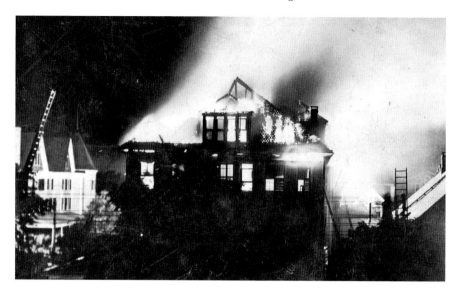

The Carleton Hotel on fire in Asbury Park in 1915. The town's late nineteenth-century frame buildings were easily set ablaze, but the 1917 fire surpassed all previous conflagrations. *Asbury Park Library.*

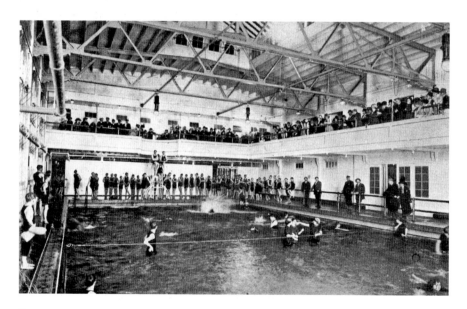

The Natatorium, the indoor swimming pool where the blaze of 1917 started via faulty wiring. *Asbury Park Library.*

Asbury Park police lieutenant William B. Rogers was the first to notice flames shooting from the Natatorium roof at the building's boardwalk entrance. Another eyewitness saw the flames spread to the second floor, bursting through windows. As beach employees frantically tried to extinguish the growing inferno, panicked bathers at the Natatorium quickly grabbed their clothing from the locker room and dashed into the chilly night air.

Within minutes, a huge burst of flames enveloped the structure, and the growing blaze, pushed by offshore winds that created an "exploding bomb" of destruction, crossed Ocean Avenue and began spreading west toward the heart of the city. The flames attacked the Murphy and Krug Amusement Hall and went on to engulf wood-frame hotels, boarding homes and residences.

Local officials quickly leapt into action. As firefighters attempted to stop the swiftly moving conflagration, Mayor Clarence Hetrick called on local National Guardsmen of the Third New Jersey Infantry Regiment's Company H to help police the city. Panic swept throughout Asbury, aggravated by the fact that the town was plunged into darkness after the Atlantic Coast Electric Light Company turned off its current due to dozens of falling wires. Residents in the path of the fire hastily removed pianos, bedroom furniture, books and other valuables from their homes, while out-of-towners were driven from the hotels, forming a "bedraggled procession" as they wandered the streets in search of shelter.

The city's firemen, meanwhile, waged a desperate battle against the relentless wall of flames, which were fanned by fifty-mile-per-hour easterly gale winds blowing in from the ocean. The fire commissioner and his men used dynamite to blow up the Ardsley Hotel, hoping to create a barrier against the flames, but the old boardinghouse was only partially wrecked by the explosives and failed to halt the advancing tide of fire. The blaze surged relentlessly toward Grand Avenue, a broad street in the heart of town lined with gracious homes and majestic churches.

It was here on Grand Avenue where the firefighters, confronted with a "seething hell of flames," attempted to stop the conflagration from heading into the heart of downtown Asbury. Armed with dozens of hoses, these brave men took a last-ditch stand across from the brick Methodist

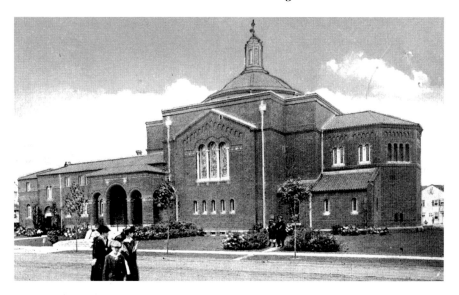

The brick Methodist church on Grand Avenue, where the 1917 fire was finally halted. *Asbury Park Library.*

church, which they hoped would serve as a blockade. Despite the prayers of panic-stricken onlookers, however, flames suddenly appeared in the roof and circular window of the church, and a burst of flame shot twenty-five feet toward the street.

The determined firemen continued to blast the blaze with water. Many of them were "burned, blistered, struck by red hot embers, [and] choked with smoke." Miraculously, their efforts paid off—the fire was indeed halted at Grand Avenue. And even more significantly, and certainly surprisingly, there were no substantial injuries or deaths.

The destruction, however, was overwhelming. The next day's *Asbury Park Press* ran a list of all the buildings destroyed, which included nineteen hotels, sixteen homes, two theaters and an amusement hall. From the boardwalk to Grand Avenue, the fire made a clean sweep of forty-eight buildings.

And yet the calamity failed to destroy the resolve of the plucky merchants and entrepreneurs who had worked tirelessly for years to build the city into a top-notch resort. Once again, the *Asbury Park Press* headline in the Saturday, April 7 edition said it all, noting that the city was "Making Plans to Rebuild as Ruins Smoulder." In fact, the owners

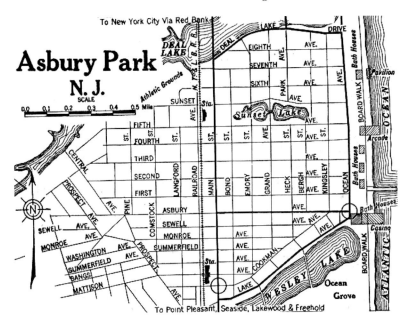

Asbury Park in 1920. The streets are as they were in the 1917 fire. *Asbury Park Library.*

of several properties destroyed by the blaze announced "the intention of rebuilding at once."

Asbury Park did indeed rebound with amazing alacrity, enjoying continued prosperity as the country glided along on the bubble of prosperity during the hedonistic 1920s. But only six years later, the city endured another blaze that almost rivaled the cataclysm of 1917. On Saturday evening, October 6, 1923, a fire began in the kitchen of the Bristol Hotel, at Fourth and Grand Avenues, quickly engulfing the frame building, which went up like a "tinder box," according to the *Asbury Park Press.* A north wind helped to spread the blaze, which destroyed numerous hotels, theaters and stores in the vicinity. Firefighters from throughout the area used their hoses to blast the blaze with water for more than thirty hours.

Other significant Asbury Park conflagrations included a 1963 fire that ravaged a portion of the beachfront, destroying nine hundred feet of boardwalk and the Asbury Avenue Pavilion. Five firemen were injured on that occasion, and damage was estimated at more than $1 million.

Although Asbury Park endured numerous other disasters, including a devastating hurricane in 1944, the fire of 1917 may be the most spectacular catastrophe that ever engulfed the city. It was an event that, in its enormous significance for the citizens of Asbury and its surrounding communities at the time, even took precedence over the country's decision to enter a world war on the front page of the local newspaper of record.

There is more on Asbury Park in the early twentieth century in Joseph G. Bilby and Harry Ziegler's Asbury Park: A Brief History *(The History Press, 2008) and in the* Asbury Park Press *of the era.*

The Plight of the Pineys

Well into the twentieth century, New Jersey's desolate stretch of southern Pinelands remained a mysterious and somewhat forbidding region, and its inhabitants—known colloquially as "Pineys"—were frequently misunderstood and reviled by outsiders.

The Pinelands, a vast swath of more than one million acres of woods, rivers, bogs and open space that occupies about 30 percent of the state's land mass, was, for many years, considered a dangerous backwoods and something of an embarrassment for "modern" New Jerseyans. Even by the late 1930s, when hard surfaced roads began to crisscross the vast area, the heart of the Pines in the area between the Mullica and Batsto Rivers was a dense scrub forest "threaded by occasional trails and a few wretched roads, unmarked and not safe for automobile travel except in dry weather," according to a 1939 New Jersey travel guide.

Here, in this secluded wilderness an hour or two's drive from the urban and suburban landscapes of central and northern New Jersey, lived the Pineys. They were the descendants of a disparate group of early colonial inhabitants, including those who came for jobs to what was then thought to be a growing industrial area due to its bog iron industry, others who left their villages as a protest against rigid religious rules and, according to legend, deserters from the British army and its Hessian auxiliary force during the Revolution. By the late 1930s, according to the WPA guide

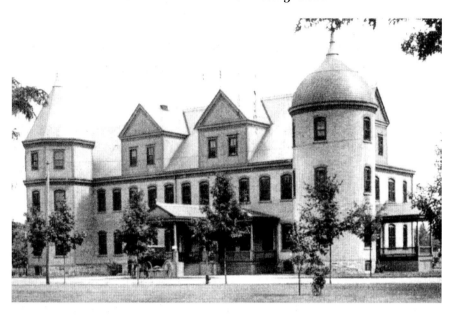

The Vineland Training School, Dr. Goddard's home base. *Friends of Historic Vineland.*

to New Jersey, it was estimated that there were fewer than five thousand of them, living in tiny shacks made of cast-off boxes and miscellaneous lumber. They earned money through various odd jobs, from cutting timber and making charcoal to gathering huckleberries and cranberries in season. To many outsiders at that time, they were considered almost subhuman creatures, plagued by degeneracy and mental deficiencies.

In truth, little was known or even speculated about these reclusive people until Elizabeth Kite, a psychological researcher, published a report called *The Pineys* in 1913. Kite worked for the Vineland Training School on the southern edge of the Pine Barrens, a state institution renowned for its clinical therapeutic treatments and research. Over a two-year period, Kite spent innumerable hours observing residents of the Pines, developing a close working relationship with many of them. She was described as a "fearless young woman who wore spotless white dresses as she rode in a horse drawn wagon through the woods," according to noted Pinelands chronicler John McPhee.

Kite's report on the Pineys was a shocking one. It told of children who shared their bedrooms with pigs, men who could not count beyond

three and a mother who walked for miles with her children every day to get whiskey. In addition, their regard for life seemed limited; one woman whose husband and children died in a fire said, "They was all insured. I'm still young and can easy start another family."

Excerpts of her unflattering report were published in newspapers around the country, spurring public outrage about what appeared to be a group of shiftless, irresponsible people who defied society's common decencies. New Jersey governor James T. Fielder toured the Pinelands to assess the situation and returned to declare that the Pineys were a "serious menace" to the state: "They have inbred, and led lawless and scandalous lives, till they have become a race of imbeciles, criminals and defectives," Fielder said. The governor even suggested that the region should somehow be severed from the rest of the state.

Kite was horrified by the negative backlash against the Pineys, contending that her report represented only a small portion of the Pinelands population. In an interview several years before her death, she stated that "[n]othing would give me greater pleasure than to correct the idea that has unfortunately been given by the newspapers regarding the Pines…I have no language in which I can express my admiration for the Pines and the people who live there."

The damaging publicity created by Kite's report was compounded by a subsequent study written by Kite's supervisor at Vineland, Henry H. Goddard, who used her findings as the basis for a report on a family he dubbed with the fictional name of Kallikak. Goddard said that he fabricated the name to avoid harming real people.

According to the theory set forth in Goddard's study, two families were descended from one man, Revolutionary War soldier Martin Kallikak. Goddard's fictionalized report theorized that Kallikak had conceived an illegitimate son through a "dalliance" with an imbecile barmaid and that her bastard son spawned generations of imbeciles, prostitutes, epileptics and drunks. Martin Kallikak, on the other hand, later married a normal Quaker girl and produced descendants who were intelligent and productive citizens. The saga of the Kallikaks supported Goddard's contention that heredity was all important and that "no amount of education or good environment could change their nature, any more

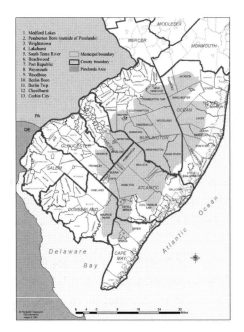

A modern map of the Pinelands area of New Jersey. *New Jersey Pinelands Commission.*

than it could change their hair color." Although Goddard's genealogical disaster was supposed to originate in Hunterdon County, the Kallikaks, no doubt due to his association with Kite and the Vineland Training School, were labeled as "Pineys" in popular culture.

Although Goddard's work, based on the discredited early twentieth-century pseudoscience of eugenics, which would become associated with Nazi "master race" ideas in later years, was eventually largely debunked, its impact—along with that of Kite's report—created a corrosive stigma that tainted the reputation of the Pinelands and its people for decades, despite the pioneering work of New Jersey reporter and folklorist Henry Charlton Beck, whose work brought the real people of the Pinelands to a wider audience. At least into the 1960s, the Pinelands was considered an eerie, backward place, as McPhee noted in his 1967 book on the Pine Barrens: "A surprising number of people in New Jersey today seem to think that the Pinelands are dark backlands inhabited by hostile and semi-literate people who would as soon shoot an outsider as look at him."

McPhee's book, a sensitive, sympathetic account of the Pines region and its inhabitants, was instrumental in helping to change public

perception. In the years that followed its publication, the area gained in status as the residents of an increasingly congested state flocked to it for hiking, camping and other outdoor pursuits. The Pinelands' country music appealed to many from outside the region as well. Many of these visitors developed a newfound respect and appreciation for Pineland culture and the people who created it, and this shift in opinion was dramatically illustrated in 1983 when the Library of Congress American Folklife Center came to New Jersey to study and document the Pinelands way of life. The original "Pineys" were, of course, merely rural people not unlike those in the Appalachians, not the mental defectives described in the work of Kite and Goddard.

Today, the Piney lifestyle that was once considered so odd and threatening—a secluded existence heavily dependent on the land and cycles of nature—is regarded by many as the representation of a unique and precious part of New Jersey's cultural heritage.

For more on the story of the "Pineys" see John McPhee's The Pine Barrens *(Farrar, Straus and Giroux, 1978),* New Jersey: A Guide to Its Present and Past, Compiled and Written by the Federal Writers' Project of the Works Progress Administration for the State of New Jersey *(Viking Press, 1939) and Marc Mappen's* Jerseyana, the Underside of New Jersey History.

Frank Hague the Benevolent

At the mention of Hudson County, New Jersey, first thoughts often turn to political corruption, stuffed ballot boxes and the rising of the dead on election day. Such stories are legendary, so much so that former New Jersey governor Brendan Byrne once quipped that when he died he wanted to be buried in Hudson so that he could "remain active in politics." The name generally associated with such stories by those steeped in the political history of the Garden State is that of the legendary Frank Hague. Despite his death more than half a century ago, the enduring reputation of political evildoing that persists regarding Hague's former northeastern New Jersey political kingdom overshadows another side of the man known in Jersey City-ese as "Duh Mare"—his positive contributions to his city and state.

Hague served an unprecedented eight consecutive terms as mayor (1917–47) of Jersey City, although he was never actually elected to that office by the city's voters. Jersey City had a commission form of municipal government, and he was, in fact, elected, along with four other men, all technically his political equals, as a commissioner. Hague's fellow commissioners and political allies invariably appointed him as commission chairman, and hence mayor of the city. They were more than willing, since Hague controlled the Hudson County Democratic Party, and a party endorsement was a must for anyone seeking office in

The young Frank Hague, ready to embark on a long political career. *James M. Madden.*

the county. "Duh Mare's" political reach eventually extended from the immigrant neighborhoods of Jersey City to the New Jersey statehouse and even to the White House.

Frank Hague was a self-made man. Born in 1876 in Jersey City to poor Irish parents, he dropped out of elementary school to work as a blacksmith's apprentice and then as a city hall janitor. Hague made up for his lack of formal education with an aggressive take-charge style and excellent organizational skills and was soon a rising member of Democratic political boss Bob Davis's organization. Elected to the city commission in 1913, he earned a reputation as a no-nonsense police and fire commissioner, purging corruption and removing muggers, prostitutes and pickpockets from the streets. The voters were impressed, and Hague used that approval to build a strong voter support base for himself, which he turned into a well-oiled political machine. Hague was in the right place at the right time and rose in a world where there was no government safety net available to the poor and near poor, the sick

and the elderly, and so he and his organization stepped in to fill the gap. The social service role that an early twentieth-century big city political organization filled is often not fully understood by modern critics quick to point out the personal corruption of a political boss.

Hague demanded results, accountability and loyalty from his subordinates, and in return he took care of their needs and those of their constituents, a recipe that kept his machine humming along through a troubled era. Although it is inarguable that "Duh Mare" became an archetypal "boss," not unlike his Republican counterpart in Atlantic City, Enoch "Nucky" Johnson, he also managed to clean up Jersey City street crime while championing the downtrodden, exploited and destitute, often Irish Catholics like himself, or other,

Frank Hague and his wife, Jennie, in the 1920s. *James M. Madden.*

Congresswoman-elect Mary Norton and Senator David I. Walsh of Massachusetts, 1924. Norton, whose career Frank Hague promoted, was the sixth woman to serve in Congress and the first female member of Congress from New Jersey, as well as the first Democratic congresswoman. *Joseph G. Bilby.*

newer immigrants, who were disparaged by New Jersey's small-town native-born Protestant population.

Hague reshaped Jersey City's municipal government, firing incompetents and political appointees from previous administrations and hiring his own loyalists to take their place. Under the new regime, city employees kicked back 3 percent of their pay to the Democratic Party as "rice pudding," a slang term also used to describe the money bartenders swept up along with beer slop as informal tips. The proceeds, along with "contributions" from merchants, contractors and others seeking favors, financed political campaigns and lined personal political pockets as well, but they were also spent to help the needy. Jersey City residents conceded that although their political leadership might have been dishonest, the dubiously acquired wealth was indeed shared. Frank Hague once said, "I

made the city. Nobody gave a damn about it before I came along." Most of his constituents agreed that Hague had indeed fixed Jersey City.

"Duh Mare" never forgot those constituents. He always strived to keep priests and women happy, in the belief that this influential alliance would keep Catholic Irish American male voters in line. On the other hand, although his police force strictly enforced laws concerning street crime, they conveniently overlooked alcohol prohibition and anti-gambling ordinances, as long as the violators kept their lawbreaking behind closed doors. To keep the city's homeowners on his side, Hague aggressively attempted to make the corporations and railroads who owned most of Jersey City's property pay their fair share of property taxes, from which most previous administrations and the state had exempted them.

Hague had a keen eye for political talent and was surprisingly progressive in his advocacy of women's rights. Women's suffrage was at the forefront of national politics in 1920, and many politicians feared that the female vote would dilute their power. Hague embraced the movement, however, seeing a new source of Democratic voters and campaign workers, and happily installed female committee members in every voting district. His most significant step in support of women's rights was taking Mary Norton on as a political protégé. Hague recognized the considerable talents of Mrs. Norton, who was active in working with Jersey City's poor and working mothers and their children. With his initial guidance, she became the first woman to serve on the Hudson County Board of Chosen Freeholders and as a member of the Democratic National Committee. Norton went on to become the first woman from an eastern state to serve in the United States House of Representatives following her election in 1924. Known as "Battling Mary" for her determined demeanor, during her first term Norton responded to a veteran congressman who asked, "Will the lady from New Jersey yield the floor?" with, "I'm no lady. I'm a member of Congress and I shall proceed accordingly."

Norton, who championed legislation improving the lot of women and working people, served in Congress through 1951. She proved an outstanding role model for women, leading the effort to attract them as Democratic Party candidates and activists. Although no puppet of the

boss, Norton championed many of the same causes Hague did. In the early twentieth century, the Jersey City hospital had gained a reputation as one of the worst places poor people could go to for treatment. As a freeholder and then congresswoman, Mary Norton helped Hague in his efforts to finance a new and improved Jersey City Medical Center with federal funding. President Franklin D. Roosevelt came to Jersey City in 1936 to personally dedicate the first three buildings of the complex.

Jersey City Medical Center, at one time reputed to have the best medical staff in the country, became a state-of-the-art hospital, where citizens were provided with excellent, and practically free, healthcare. The center was also an architectural wonder, with quarter-inch-thick imported terrazzo marble floors and walls, wood-paneled offices and solid bronze doors, courtesy of the New Deal. The mayor who had made it all happen took a special interest in the facility, naming the maternity building the Margaret Hague Maternity Hospital, where "mothers could have their babies for free on Mayor Hague," after his own mother. It was both a tribute to a mother who had taught him that women should be treated fairly and well and a reminder to the city's mothers that they owed this free service to the Democratic Party and Mayor Hague, who would appreciate their votes in return. "Duh Mare" remembered those women as their children grew older, as well. During World War II, Frank Hague was the only public official in New Jersey who saw to it that female war workers received free child care.

There are other, more personal, stories of Hague's benevolence. In December 1943, a severely ill young Gerald Madden was rushed to Jersey City Medical Center, where he was diagnosed with a life-threatening ruptured appendix. Madden's poor Irish immigrant family had no money to pay for the extensive care needed but understood that Mayor Hague's new hospital was the place to go for good care at minimal cost. Hague's world-class hospital had acquired a new wonder drug, largely restricted to military use at the time. A dose of penicillin quashed the infection and saved young Gerald Madden's life.

Gerald vividly remembered the hospital staff snapping to attention when the mayor, who maintained a satellite office in the hospital, made his rounds. Hague wore a stiff high collar and carried his fedora hat in hand, walking through the boys' wards and stopping at each bed to chat.

Young Gerald M.
Madden, whose life
Hague's medical
center saved. *James
M. Madden.*

During his several-week stay, which extended over Christmas, Hague
visited Madden's ward many times, handing small gifts to the young
patients and creating a lasting memory. Mayor Hague gave young Gerald
the best Christmas gift of all—the gift of life.

The Madden family never saw a hospital bill and recalled ever after
that their mayor saved their child. Author Jim Madden, born in the
Margaret Hague Maternity Hospital, grew up hearing those stories.
The tales of Frank Hague's good deeds have been largely lost to history,
overshadowed by stories of his political corruption, but many families
have recollections of the better angels of his nature. Politicians, even
those largely remembered for their faults, are often complex, multifaceted
people. For all his faults, and there were many, it should be remembered
that Frank Hague also had a good side.

Today, the medical center has moved, but Frank Hague's solid and
striking old Art Deco complex remains. Some of the buildings have
been transformed into luxury condos. The Margaret Hague Maternity
Hospital still stands, her name carved in granite above the door in

perpetual memory of "Duh Mare" and his sainted mother. Somewhere, someplace, he's smiling.

Thomas Fleming's Mysteries of My Father *(Wiley, 2005) provides an insightful look at growing up in Hague's Jersey City reign. Numerous articles on the man and the era are available in the* New York Times *and in* Time *magazine, including "Rice Pudding—with Raisins" in the latter publication on July 3, 1950.*

Taking the Plunge in Atlantic City

The scene was perhaps the most breathtaking of all the outlandish exhibitions that defined the riotous, carnival-like atmosphere of Atlantic City during its heyday in the 1920s and '30s. A fascinated crowd of up to five thousand spectators watched avidly as a young woman in sequins climbed a narrow ramp. As she reached the top, a trainer swatted a large, magnificent horse, which raced up the slope toward her. The woman quickly mounted the animal and, amid the gasps and cries of the onlookers below, plunged more than forty feet, crashing into a twelve-foot-deep pool of water.

For years, Atlantic City was renowned for its Diving Horse act, one of the biggest crowd-pleasers at the two-thousand-foot-long Steel Pier, a boisterous amusement center with attractions ranging from wild animal acts to human cannonballs. "Among [the Pier's] novelties are three diving horses that, four times a day, gallop up a runway 45 feet high and dive into a pool of water, a girl rider perched on each back," noted a 1930s travel guide.

The wildly popular act was the brainchild of William F. "Doc" Carver, a former show business partner of Buffalo Bill Cody. Carver, a one-time dentist turned performer, began his entertainment career with trick shooting exhibitions in the late 1870s. Carver allegedly invented the Diving Horse act in 1881 after a wooden bridge buckled under him and

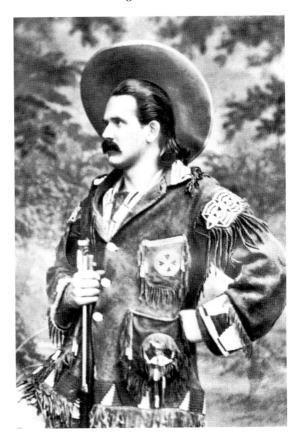

William Frank "Doc" Carver, trick shooter, showman and Sonora Webster Carver's father-in-law, invented the Diving Horse act and brought it to Atlantic City. *Joseph G. Bilby.*

his horse, plunging the two into Nebraska's Platte River. Inspired by the hair-raising incident, according to the story, Carver turned it into an act for county fairs.

Unfortunately, the dangerous act was not without serious risks. Tragedy struck in 1907, when "The Great Carver Show" appeared in San Antonio, Texas. One of the horses made a poorly executed jump from the four-story platform, killing Oscar Smith, the eighteen-year-old rider. The show, however, did go on; two days later, an advertisement pledged that "the Five High Diving Horses will dive."

Although Carver died in 1927, the most memorable era for his unusual act was yet to come. Entrepreneur Frank P. Gravatt, an Atlantic City hotel builder, was intrigued by the daring display and lured the act to the Steel Pier in 1928. Such a proposition was undoubtedly attractive, for the pier

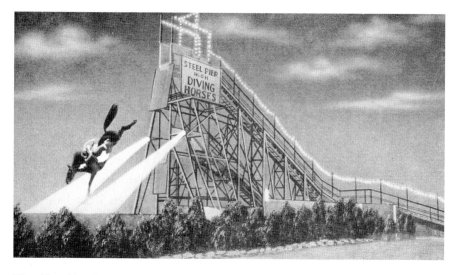

The girl and her horse dove from a sixty-foot tower. *Joseph G. Bilby.*

was Atlantic City's prime venue for honky-tonk entertainment during the 1920s. It was a clattering, clanging showplace of constant stimulation, with its endless stream of novelty acts, movies and vaudeville. The Diving Horse act was a natural addition to the eclectic lineup of trained seals, incubator babies and the "High Diving Hawaiians."

The fearless young women who rode the diving horses were an essential part of the act. They included Sonora Webster, an indomitable performer whose colorful life would inspire the 1991 Disney movie *Wild Hearts Can't Be Broken.* Webster, one of six children in a working-class family from Georgia, first joined "Doc" Carver's act in the early '20s after reading an advertisement that called for a girl who could "swim, dive and was willing to travel." She and her sister, Annette Webster French, were among the first riders to popularize the Atlantic City act.

Like her fellow performers, Webster endured an arduous training period, learning to ride horses without bridles or saddles and practicing from a "lower" tower of twelve feet before progressing to one that loomed more than forty feet. Sonora Webster's determination and abilities earned her a place as one of the troupe's star performers. Several years after joining the group, she also became a member of the family, marrying "Doc's" son, Al, and becoming Sonora Webster Carver.

It was a tragic accident, however, that thrust Sonora Carver into the media spotlight and added another dimension of notoriety to the act in the years that followed. In 1931, Carver was performing with one of the show's horses, Red Lips, when the animal dove too steeply. Carver crashed face-first into the water, suffering detached retinas that left her blind. Yet remarkably, after a period of recuperation, the resilient Carver insisted on continuing with the show. She kept making the dangerous dives for rapt audiences until the early days of World War II.

Following her departure, other brave young women joined the act, which continued into the 1970s, when pressure from animal rights activists who feared for the horses' safety effectively shut down the show. Sonora Carver, however, always insisted the horses loved performing and were never forced to jump.

The demise of the Diving Horse act was another reminder of the changing face of Atlantic City, which for decades had been an oasis of fun and fantasy for the masses, a "carnival city as characteristic of this country's culture as Brighton or the Riviera's are of Europe," as a 1930s travel guide noted. By the '70s, however, the carnival city was a scarred and forgotten victim of urban blight, making the uneasy transition to a gambling town of slick casinos. The decrepit Steel Pier, which underwent a hasty makeover in anticipation of the anticipated casino crowd, eventually became a helipad under the mandate of high-roller investor Donald Trump.

As for Sonora Carver, she and her husband moved to New Orleans in the 1940s, where Carver learned Braille and worked as a Dictaphone typist until her retirement in 1979. She also found time to write an autobiography about her heady days as a star of the Diving Horse act, entitled, *A Girl and Five Brave Horses*. She lived to hear actress Gabrielle Anwar portray her in *Wild Hearts Can't Be Broken*, a romanticized version of her horse jumping days.

Carver's final years were spent in a Pleasantville, New Jersey nursing home, where she died in 2003 at the age of ninety-nine. Numerous newspapers featured obituaries on the courageous girl who helped define an era of spectacular entertainment during the heady days of Atlantic City's prime.

"She represented courage, fearlessness, but also the fun of the times," noted her nephew, Donald French. "She represented Atlantic City at the height of an era."

There are several good books on Atlantic City, and we recommend the following: Charles E. Funnel's By the Beautiful Sea: The Rise and High Times of that Great American Resort, Atlantic City *(Rutgers University Press, 1983); Nelson Johnson's* Boardwalk Empire: The Birth, High Times and Corruption of Atlantic City *(Plexus Publishing, 2002); and Bryant Simon's* Boardwalk of Dreams: Atlantic City and the Fate of Urban America *(Oxford University Press, 2004).*

The Once and Future Governor

A. Harry Moore

Arthur Harry Moore was born in Jersey City, New Jersey, on July 3, 1879. A. Harry, as he preferred to be called, would eventually become New Jersey's champion governor, if such a title existed, serving three three-year terms for a total of nine years, a combination of terms and time that will, due to constitutional changes, likely never be repeated.

Initially, such a future seemed improbable, as Moore, born into a working-class family of Scottish and Irish heritage, left school for work at age thirteen. From the start, though, he manifested a good deal of ambition, and while working as a clerk he took courses in bookkeeping and other office skills at New York City's Cooper Union. Active in politics early on, Moore earned the friendship of H. Otto Wittpenn, a name that suggests a Hackensack River bridge to modern New Jerseyans but who was a rising Progressive Democrat politician in the early twentieth century. Elected as mayor of Jersey City in 1907, Wittpenn hired his young protégé as his secretary and later appointed him city collector. Moore first ran for public office in 1913, when Jersey City adopted the commission form of government. As commissioner of parks and public property, he established a reputation as "the kiddies' friend" through an expansion of the city's public park system and because of his advocacy of recreational programs for children.

By all accounts a good-natured and personable politician, Moore made friends easily, but his most significant political alliance was with Jersey City political boss Frank Hague. The popular Moore, running for commissioner with Hague's endorsement, proved the top vote-getter in the Jersey City elections of 1917, 1921 and 1925. Although lacking a college degree—or, for that matter, a high school diploma—he attended New Jersey Law School part-time, passed the state bar examination in 1922 and earned a degree in 1924.

Hague, whom his fellow commissioners perennially elected mayor, knew a winner when he saw one and encouraged his ally to run for governor in 1925. Moore ran on an anti-prohibition "wringing wet" platform and won, thanks to the vote plurality he received from solidly Democratic Hudson County. In office, the new governor proved, much to Hague's delight, a reliable organization man, showering job appointments on the Democratic faithful. In his governance, however, Moore promoted bipartisan cooperation with the Republican-dominated legislature, provoking minimal confrontations over policy. He actually proved more fiscally conservative than the Republicans on some issues. In one instance, Moore opposed a bill providing state funding to build a modern automobile-friendly highway system because he believed that the gasoline tax necessary to finance it would be too great a burden on the public. On another occasion, he advocated local "home rule" over a comprehensive state plan to provide potable water supplies to New Jersey's citizens. It should be noted that Moore's "home rule" philosophy may well have been due as much to the wariness of Jersey City Democratic politicians concerning state control resulting from Trenton's takeover of the city in the late nineteenth century as it was to his innate conservatism.

The Roaring Twenties were high times in New Jersey, where neither Democrats nor Republicans were enthusiastic about the Eighteenth Amendment and its enabling Volstead Act. Money and booze flowed freely across the state, and lawlessness skyrocketed. Although he opposed prohibition, Moore expanded the state police to combat crime resulting from it and took a personal interest in notorious incidents like the Hall-Mills murder case and the "Battle of Jutland," in which misinformed

UNBOSSED TICKET

"RECORD" HAS A TICKET
"WITTPENN" HAS A TICKET
"VERDON" HAS A TICKET

THIS IS THE PEOPLE'S TICKET
FOR COMMISSIONERS

GEORGE F. BRENSINGER
Com. of Revenue and Finance, who reduced your taxes and placed Jersey City on a sound financial basis.

A. HARRY MOORE
Com. of Parks and Public Property, who gave you beautiful Parks, Playgrounds and Public Buildings. "The Kiddies' Friend."

FRANK HAGUE
Com. of Public Safety. He eliminated politics and gave you a most efficient Police and Fire Department.

MICHAEL I. FAGEN
Present City Clerk and Authority on Municipal Law. Experienced and Efficient.

CHARLES F. X. O'BRIEN
The Judge with a human heart. The poor man's friend.

Frank Hague and A. Harry Moore ran for commissioner jobs on the same ticket in Jersey City, 1917. *James M. Madden.*

members of the state police shot up a farmhouse and killed an innocent woman in Hunterdon County.

The governor's summer home, located on the National Guard campgrounds at Sea Girt, bustled with military reviews and hosted a

Governor A. Harry Moore greeting National Guard soldiers as they march into the camp at Sea Girt in 1926. *National Guard Militia Museum of New Jersey/Sea Girt.*

stream of visiting political leaders and celebrities, and 1928 was a particularly busy year. On July 22, a plane bearing humorist Will Rogers landed on the Sea Girt parade ground. After dining with Governor Moore, Rogers received a state police escort to a speaking engagement at Ocean Grove. On August 2, famed aviatrix Amelia Earhart performed aerial acrobatics above Camp Moore (the camp was always named for the sitting governor) following a state Democratic Party rally. The largest event of the season at the summer capital that year was the massive campaign rally that Moore and Hague organized for Democratic presidential candidate Al Smith on August 25, with more than eighty thousand people in attendance. Although the governor and his wife, Martha, were childless, he maintained a lifelong interest in child welfare, especially for disabled children, and held an annual "Crippled Kiddies Day" at Sea Girt.

Since the New Jersey Constitution, adopted in 1844, provided that a governor could not succeed himself after a three-year term, Moore

returned to Jersey City in 1929, where he practiced law and became a speaker much sought after. He also kept his name in the public arena with a Saturday evening show on WOR radio. In 1931, in honor of his work for disabled youth, Jersey City opened the A. Harry Moore School for Crippled Children. It was also an election year, and Moore was ready for another campaign for governor. His political chances were greatly enhanced by the fact that he was a Democrat running in a deepening Depression that voters blamed on Republicans. Moore won his second term in a landslide, with the largest plurality of votes in New Jersey history. Once in office, his approach to the Depression was, ironically, a somewhat conservative one, as he cut state spending while attempting to funnel remaining available funds to distressed municipalities to use for local welfare assistance, another example of his "home rule" philosophy. At the same time, he advocated a sales or income tax to provide stable state funding, a policy that found no support among Republicans. A graduate of the Frank Hague school of politics, Moore retained his personal touch with voters, listening to their stories and often intervening in individual cases. In a nationally publicized event at Sea Girt on August 28, 1932, Moore and Hague trumped their previous Al Smith rally with a massive gathering for Franklin D. Roosevelt, as more than 100,000 people came to the little seaside town to support the Democratic presidential candidate.

Although Roosevelt's election spelled the end of prohibition, in the early 1930s Governor Moore had his hands full with Depression woes. He still found time to participate in headline-making New Jersey stories, however, personally directing the state's law enforcement officers in their investigation of the Lindbergh baby kidnapping in 1932. Moore was at his beloved Sea Girt summer home when the cruise ship *Morro Castle* burned directly offshore in September 1934. Upon hearing the news, the governor reacted quickly, ordering soldiers training at the camp to deploy along the beach to aid survivors. He then commandeered a National Guard pilot and plane, jumped in the observer's seat and flew off into heavy winds to circle the ship and personally drop markers to direct rescue vessels.

Perhaps sick of the lack of progress in fighting the Depression in Trenton, Moore, again at the encouragement of Frank Hague, ran for and was elected as a United States senator from New Jersey in 1934. Mr.

Moore went to Washington, but he didn't stay. A conservative Democrat from a simpler age, Moore was essentially a devolutionist who was uncomfortable with efforts to centralize political and economic power in either Trenton or Washington. Although he did his part in garnering WPA construction projects, including Jersey City's Medical Center, National Guard Armory and Roosevelt Stadium, he was out of touch with the mainstream of his party in the depths of the Depression and was the only Democratic senator to vote against the Social Security Act of 1935.

Halfway through his term, the unhappy Moore decided, with encouragement from Hague, that state government was a more fitting arena for his talents and ran for governor again in 1937. Campaigning for an unprecedented third term, he was attacked by resurgent Republicans as well as Democrats unhappy with his lack of enthusiasm for certain aspects of the New Deal. Moore won the election due to heavy voter turnout in Hudson County, but there were accusations of voter fraud by his opponent. An investigation ended in 1940 when a mysterious fire destroyed the ballots. Moore's subsequent appointment of Frank Hague's son to the New Jersey Court of Errors and Appeals (today's Supreme Court) did nothing to dispel the fraud charges.

Despite a shady election result, Moore plunged back into his first love, state governance, advocating work relief programs for the unemployed with some success. His recurrent desire to create a modern tax base to support necessary state spending on education foundered once more when it was countered by a Republican move to raise funds through the restoration of racetrack gambling. Horse race betting had been banned in the state since the 1890s, when gambling interests had totally corrupted the legislature. The restoration of parimutuel betting was approved by the voters in a referendum in 1939, however, and New Jerseyans could once more play the ponies. With the advent of war in Europe in September 1939, Governor Moore worked hard to prepare the state for what he saw as an inevitable conflict and established the first civil defense structure in the nation, the New Jersey Defense Council. In September 1940, with war clouds darkening the horizon, Moore signed an order officially calling up New Jersey's National Guard for one year of federal service. That year would stretch to five before the state's soldiers came home. In

Left to right: Governor Moore, Franklin D. Roosevelt and Frank Hague at Sea Girt, August 28, 1932. *Franklin D. Roosevelt Library.*

January 1941, he left the statehouse for the last time, passing the office on to Democrat Charles Edison, son of the famed inventor.

Although Frank Hague, unhappy with the uncooperative Edison, encouraged a fourth Moore run for governor in 1943, the veteran politician refused. Moore maintained a residence and lucrative law practice in Jersey City and remained a popular public speaker at events around the state, and he and his wife purchased a country home in Hunterdon County. Moore, always personally popular with politicians of both parties, was named to the state board of education by Republican Governor Walter Edge in 1945. He died on November 18, 1952, of a stroke suffered while driving near his Hunterdon County home.

Prohibition, depression and war. The nostrum "may you live in interesting times" may well be a modern construct rather than an old Chinese saying, but it would certainly be applicable to the career of A. Harry Moore. The three-time governor's name, if not his memory, is preserved in the A. Harry

Moore loved a plane ride. Here he is in the observer seat of a New Jersey National Guard plane flying out of Newark airport in 1933. *National Guard Militia Museum of New Jersey/Sea Girt.*

Moore Laboratory School, which evolved from the original A. Harry Moore School for Crippled Children and is now operated by New Jersey City University College of Education. The school, faithful to Moore's great cause, offers "academic, therapeutic, pre-vocational and social programs for preschool disabled, learning and language disabled, and multiply disabled" students. Whether passersby who see the former governor's name atop the door have any idea of who he was is debatable. A. Harry Moore, one of the most popular Jerseymen of his generation, deserves better.

The best synopsis of A. Harry Moore's career is found in the essay by Richard J. Connors in Paul A. Stellhorn and Michael J. Birkner's The Governors of New Jersey 1664–1974: Biographical Essays *(New Jersey Historical Commission, 1982). The* Quiet Hour *(MacCrellish & Quigley, 1940), a laudatory biography by a friend, Fred J. Bloodgood, provides good anecdotal material but should be read with the proverbial grain of salt at hand.*

THE KLAN COMES TO
NEW JERSEY

From far away across the farmland of Wall Township, New Jersey, or from across the Shark River in Neptune, you could see the electric light bulb–lit cross, glowing eerily in the night sky. It was a fifty-foot-high symbol of the Ku Klux Klan, which, through a front organization, the Monmouth Pleasure Seekers Club, owned it in addition to close to four hundred acres of land on the south bank of Shark River inlet in Wall during the 1920s. The area, formerly the site of Guglielmo Marconi's transatlantic wireless station, became a local headquarters for the Klan and was planned as the site of an eventual summer resort for vacationing Klansmen from around the state and beyond. The Klan, in this, its second incarnation in America, was a band of self-righteous white-hooded figures portraying themselves as defenders of white-bread "one hundred percent Americanism" against "uppity" African Americans, Catholics, Jews and immigrants, and it was riding high in those early years of the Roaring Twenties.

The rolling property above the banks of the Shark River, which included a hotel, a power plant and a handful of wooden outbuildings, became a central location for Klan rallies and festivities at a time when the organization exerted a strong influence on the Shore area. According to a 1926 *New York Times* article, "Only members of the Klan or affiliated organizations are admitted to the 396-acre reservation." The enclave

An early Klan rally at Far Hills, New Jersey, in 1920. *Rutgers University.*

hosted a wide variety of Klan activities, from summer circuses and carnivals to appearances by Klan celebrities, including Imperial Wizard Hiram W. Evans of Illinois. During the hectic Jersey Shore week of July 4, 1926, Evans arrived by airplane to address patriotic services at the Klan headquarters housed in the old Marconi hotel. His appearance was part of a three-day Klan celebration that kicked off with a ball in honor of "Miss One-Hundred Per-Cent America." Other activities included a parade that wended through Neptune and Avon.

Such brazen displays by a group known for its innate bigotry and occasional violence had become increasingly commonplace for the

Klan, which began its march to what would become considerable power in 1915, when sometime salesman and defrocked Methodist minister William J. Simmons—who had, until that moment, made it through life on the proverbial "shoeshine and a smile"—climbed Stone Mountain, Georgia, burned a cross and proclaimed himself the "Imperial Wizard" of the Ku Klux Klan. Simmons sought to revive the original hooded order, which had appeared in the South during the Reconstruction era of the late 1860s and early 1870s. He was inspired by, among other things, D.W. Griffith's 1915 film *The Birth of a Nation*, a pseudohistorical epic about the Civil War and Reconstruction that depicted the Klan as a noble organization attempting to salvage the traditions of the Old South by returning white rule and economic hegemony to the former Confederate states in the postwar years, while at the same time denigrating the moral character and competence of African Americans.

After a slow start, the new Klan came under the sway of public relations pioneers Edward Y. Clarke and Elizabeth Tyler, who turned it into a national organization and, for them, a very profitable business. In the post–World War I world, the Klan attracted large numbers of native-born, white Anglo-Saxon Protestants who were disturbed and offended by the dizzying changes, actual and perceived, wrought by immigration, industrialization and urbanization in American society. The increasing numbers and influence of immigrants and a deep-seated antipathy toward African Americans, traditional scapegoats of many in nineteenth-century white America, fueled the growth in Klan numbers as the organization spread nationwide.

Perhaps surprisingly to modern readers, New Jersey did not escape the expansion of the Klan. In fact, it provided fertile ground for Klan "Kleagles," or recruiters. Many of the state's small-town native-born Protestants, increasingly anxious since the late nineteenth century about the tide of immigrants flowing into cities like Newark, Trenton and Jersey City (in 1920, 20 percent of the state's residents were foreign born, and many more had parents born abroad), were ready to don a hood.

Needless to say, not everyone in New Jersey was enthused. A 1921 article in the *Jersey City Journal* warned that "[t]he Ku Klux Klan, born in the South during the dark days of reconstruction, has been revived

New Jersey KKK
grand dragon
Arthur H. Bell of
Bloomfield and
his wife, Leah,
as YMCA troop
entertainers in 1919
before they joined
the Klan. *Aloahwild.*

and is to invade the North…A branch is to be organized in New York. Presumably, branches in the larger New Jersey cities are expected to follow speedily." Several months later, Trenton's director of public safety warned that there would be "bullets for the Ku Klux Klan" if the group's attempt to establish itself in the city initiated a race war. Certainly, African Americans had great reason for concern at the expansion of the Klan; sixty-five people, most of them black, were lynched in the United States in 1920 in horrific incidents involving hanging, shooting, burning, drowning and flogging.

Despite the efforts of many authorities to halt its rise to power, the Klan initially prospered in New Jersey. By the early 1920s, the organization

Bishop Alma White, founder of the "Pillar of Fire" church, located in Zarephath, Somerset County, New Jersey, authored screeds on the Catholic-Jewish plot to take over America and posited that racial equality was a violation of "Holy Writ." White was a close Klan associate who sponsored KKK rallies, and Arthur Bell usually contributed forewords to her publications. The Klan funded her Alma White College. *Wikimedia Commons.*

was established in pockets throughout the state, including suburban communities like Bloomfield, where New Jersey grand dragon Arthur Bell resided. The organization was especially strong in suburbs surrounding the industrial cities, in rural areas and in religious vacation spots like Ocean Grove. Evangelical Christians seemed particularly susceptible to Klan persuasion, and "Bishop" Alma White of the "Pillar of Fire" church in Somerset County was an early enthusiast; in return, the Klan financially supported her educational endeavors. White complemented the Klan program by publishing works condemning "the unrepentant Hebrew" in collusion with Catholics to dominate America, as well as extolling white supremacy. Long Branch, once the gambling capital of New Jersey, hosted the "Tri-State Konklave" over the Fourth of July weekend of 1924, with Klan sporting events and parades, including a "ministers' race." One account has more Klansmen in New Jersey than in Georgia in the early 1920s.

The Klan attempted to soften its harsh image by portraying itself as a charitable and patriotic organization, giving money to churches and children in need, provided they met Klan criteria. On one occasion, hooded Klansmen appeared in the aisles of a West Belmar Methodist church to hand over a sum of money to the church's pastor. Efforts to clean up its image could not alter the fact that the Klan was linked to lynching, kidnapping and murder in states such as Georgia, California and Texas, however. Such extreme violence was never reported in New Jersey, although occasional Klan-administered beatings of drunks considered irresponsible spouses are recorded in local folklore. The Klan's primary thrust in New Jersey was promoting the restoration of a mythical era of white Protestant morality and attempting to influence government to actively promote that worldview. The efforts were varied, from pressuring the Bloomfield Board of Education into pulling the *Catholic Encyclopedia* from its school library bookshelves to invading a black church in Belmar to lecture the parishioners on the righteousness of white supremacy. The group's presence was pervasive enough in the rural areas inland from the Jersey Shore to dissuade some Catholics and Jews from vacationing at the beach resorts. On one occasion, Klansmen attempted to stage a failed coup by impeaching the mayor of Asbury Park.

While its Wall Township vacation headquarters served as a prime location for Klan gatherings, members of the group also conducted numerous meetings and initiations throughout the state, using an elaborate and secret system in which members were "notified of initiations and other gatherings by mail or over the telephone," with the messages relayed in "Klan lingo," according to a 1923 *New York Times* report. At a rally in Point Pleasant, a Klan leader ranted about "eighty-seven thousand cases of white girls living with negroes and men of the yellow race," and other Klan speakers enlightened the faithful about sinister plots by Catholics and Jews to infiltrate the United States military.

Despite its seemingly powerful grip, however, internal and external pressures began to dismantle the Klan regime's in New Jersey by mid-decade. In 1923, 1,000 people attacked a "Pillar of Fire" Klan rally in Bound Brook. That same year, a mob of angry Perth Amboy residents,

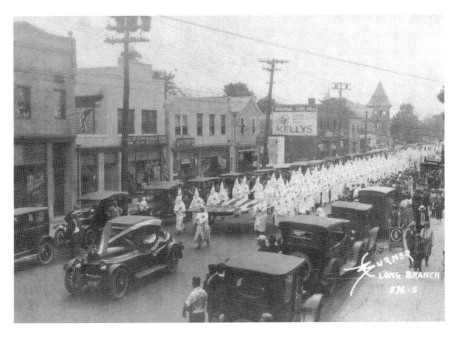

Ku Klux Klansmen from New Jersey, New York and Pennsylvania marched in Long Branch on July 4, 1924. *Joseph G. Bilby.*

many of them immigrants or the children of immigrants, assaulted 250 Klansmen parading through town. In addition, many public officials were quick to denounce the Klan, including the mayor of Atlantic City (whose constituents were 50 percent African American), who instructed his policemen to "break your clubs over their heads."

By 1926, public intolerance of the Klan began to grow throughout the country; a nationwide newspaper survey indicated that "ridicule and dissension have caused membership to drop." On a national level, various ranking Klan officials were ensnared in embarrassing fiscal and sexual scandals, and in New Jersey, internal politics and greed began to unravel the empire.

At the Wall Township encampment, infighting and property ownership disputes over the sprawling Klan tract led to a flurry of lawsuits that further tore the group apart. The Klan's influence lingered, in a diminished form, on into the 1930s, but eventually the Wall land was sold to the Young People's Association for the Propagation of the Gospel, a group

that established a Christian Bible college on the site. During World War II, it became a substation of Fort Monmouth, as Camp Evans, which it remained until being turned over to local and county government use upon the closure of Fort Monmouth.

Despite its rapid decline, the Klan continued to make public appearances in New Jersey, including an infamous joint rally with the German-American Bund, an American version of the Nazi party, at Camp Nordland, a Nazi summer camp in Andover, in August 1940, as World War II raged in Europe. Its remaining influence evaporated as the country entered into a world war that required national unity as opposed to dissension.

Yet the hatred and bigotry fueled by the Klan never quite dissipated. Although its electric cross no longer shone across the empty fields of

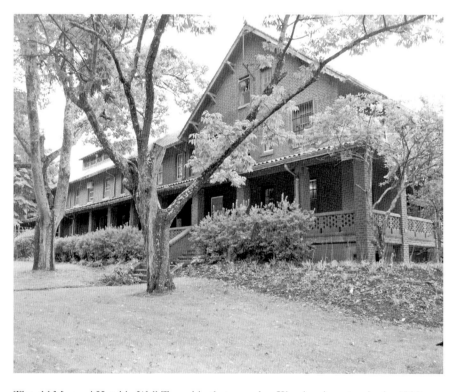

The old Marconi Hotel in Wall Township that served as Klan headquarters in the 1920s still stands. It eventually became part of the army's Camp Evans and is now the site of a communications museum, Info Age. *Joseph G. Bilby.*

Wall Township at night, there were other crosses that delivered the same message. In 1948, several years after the war, a twelve-foot cross burned in front of the home of Leroy Hutson, a black radio engineer who lived only a few miles from the former Klan enclave and who worked there as one of the many men and women employed at Camp Evans, then a high-level army research facility.

Described by state police as a "decent man," Hutson, who lived in Wall Township with his wife and infant son, discovered the fiery cross blazing outside his living room window. "It was a terrifying experience," he said, although he noted that he had no intention of moving. State police placed a guard on Hutson's residence and made the rounds of surrounding homes, warning neighbors to keep off his property.

The nights of Klan revelries and rallies along Shark River may have been long gone, but the chilling incident involving Huston was a grim reminder that their message still lingered, beneath the surface, a beast always waiting to be awakened.

The book on the Ku Klux Klan in New Jersey has yet to be written, but the Bernard Bush Collection on the Ku Klux Klan in New Jersey (1915–1946)—*entailing a lifetime of Mr. Bush's work collecting primary sources and housed at Rutgers University's Alexander Library in New Brunswick—is a treasure-trove on Klan activities in the state.*

Heroes of the *Morro Castle*
The First Separate Battalion

While African American New Jerseyans were drafted in large numbers into the segregated national army in World War I, and the state raised segregated home guard units during the war, these detachments were disbanded in January 1920, leaving the New Jersey National Guard a completely white organization.

Although there appeared no chance of a "colored" unit being authorized in the New Jersey National Guard by federal authorities, African American citizens, as well as both white and black World War I veterans, most notably William D. Nabors of Orange, petitioned the state's adjutant general and their state legislators to create a totally state-funded organization. Assemblyman Frank S. Hargraves introduced such a bill, and on April 16, 1930, the New Jersey legislature passed Chapter 149, Laws of 1930, authorizing the "organization and equipment of a battalion of Negro infantry" at state expense.

On July 14, 1931, committees were established to organize the first companies of what came to be called the First Separate Battalion, New Jersey State Militia. Shortly afterward, sixty-three Essex County men enlisted in Company A, which established headquarters in Newark in a former theater at the Amsterdam Building, located at 83 Sixteenth Avenue, at the corner of Littleton Avenue. The company was formally mustered into service on September 25, 1931. Company B was mustered

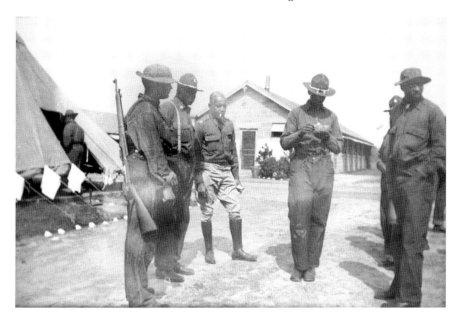

Soldiers of the First Separate Battalion preparing to go to the rifle range at Sea Girt in the 1930s. *National Guard Militia Museum of New Jersey/Sea Girt.*

in on September 23 in Atlantic City, with its armory located in a building at Kentucky and Adriatic Avenues. Both companies subsequently received their initial training at the New Jersey National Guard's training camp at Sea Girt. The battalion's Company C was organized at Camden in 1933, and Company D, later designated the battalion heavy weapons company, was raised in Trenton in 1935. A battalion headquarters detachment was established in Atlantic City in 1934, and the battalion eventually added a band based in Atlantic City and a medical detachment in Newark.

Companies A and B were at the Sea Girt National Guard Camp for their annual field training on September 8, 1934, when the cruise ship *Morro Castle*, returning to New York from Havana, caught fire offshore. As its control systems burned, the ship anchored two miles off Sea Girt in turbulent seas, and desperate passengers and crew members tried to launch lifeboats or jumped overboard in efforts to save themselves from the flames. The disaster would prove to be the finest hour for many New Jersey shore residents, including Governor A. Harry Moore, who was ending the season at his official summer residence in the National

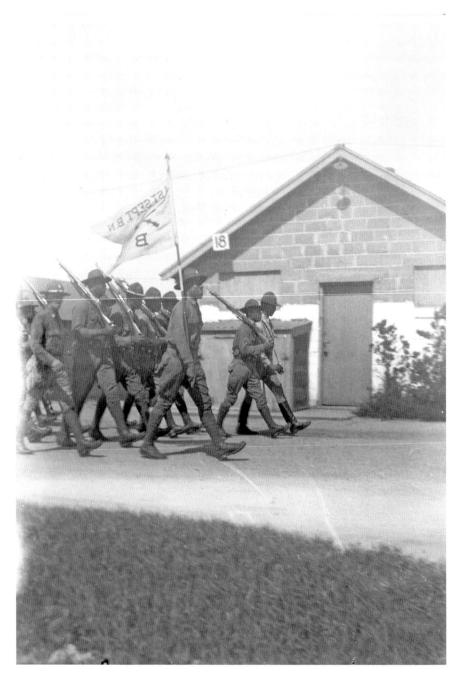

B Company, First Separate Battalion, on parade at Sea Girt in the late 1930s. This Atlantic City company was a favorite unit of famed Atlantic City politician Enoch "Nucky" Johnson. *National Guard Militia Museum of New Jersey/Sea Girt.*

Guard camp. Moore boarded a Guard plane in the observer seat and flew out over the burning ship, dropping smoke bombs and waving flags to indicate survivors to rescue boats.

Before he soared aloft over the surf, the governor ordered the black militiamen to fan out along the coast from Belmar to Manasquan. The soldiers of Companies A and B braved almost hurricane conditions along the shore, not resting until they rescued the survivors and recovered the dead that drifted onto the beach. Some of the men, morticians in civilian life, established an improvised morgue in several Sea Girt camp buildings, which were soon filled with seventy-eight bodies. Anxious relatives who soon appeared at Sea Girt to identify the dead were guided by the black soldiers, with nurses on hand for support. On September 10, the remaining bodies were moved to Jersey City by train. Companies A and B were subsequently cited by Governor Moore and the state legislature for their "courage, courtesy, and sympathetic handling of a very gruesome duty," and the city commissioners of Atlantic City presented Company B with a bronze plaque "in recognition of its heroic and devoted services to the community, state and nation."

The battalion also distinguished itself in other venues, winning numerous athletic and marksmanship trophies. Company A boasted the largest percentage of men to qualify in rifle marksmanship in the state, won the Enoch ("Nucky") L. Johnson Trophy for shooting expertise six years out of nine and took the battalion's Combat Trophy in 1932 and 1933. In the National Guard "small bore"(.22 rimfire caliber) rifle match of 1940, six out of the highest ten scores were posted by men from Company C.

In 1936, the adjutant general persuaded the New Jersey state senate to redesignate the battalion as an adjunct unit of the New Jersey National Guard, and in May 1937, the First Separate Battalion, New Jersey State Militia was renamed the First Battalion, New Jersey Guard. Although the battalion's "acting commander and instructor" was always a white officer, Major Samuel Brown in 1940, all company officers were African Americans.

With the approach of World War II, the battalion was formally accepted by the federal government as a National Guard unit and renumbered as the 1st Battalion of the National Guard's 372nd Infantry

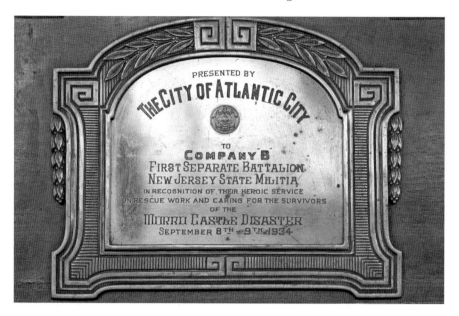

Bronze plaque awarded to Company B by the Atlantic City government for the company's role in rescue operations at Sea Girt in the wake of the *Morro Castle* ship fire disaster. *National Guard Militia Museum of New Jersey/Sea Girt.*

Regiment, composed of African American guardsmen from the District of Columbia, Maryland, Massachusetts and Ohio.

The 372nd was ordered into United States federal service on March 10, 1941, and was initially stationed at Fort Dix, assigned to the Eastern Defense Command's First Army as part of an internal defense force for the Greater New York City area. As such, the battalion was stationed in New York and New Jersey for three years. It later became a training unit and, in April 1944, also a "rotational regiment," which moved about the country to posts in Kentucky, Arizona and Washington until arriving in Hawaii in April 1945 to prepare for the invasion of Japan. With the end of the war, the regiment returned to New Jersey and was deactivated at Fort Dix on January 31, 1946. Following the war, many returning black veterans joined the 1st Separate Battalion's successor unit, a segregated antiaircraft battery.

The post–World War II era dawned with a new realization that the promises of the Civil War could no longer be denied, and the civil rights movement gained new strength based on the wartime sacrifices made by black men and women in defense of the country. In 1947, New Jersey

adopted a new constitution, replacing the previous constitution of 1844 and specifically forbidding racial discrimination. With this in mind, and considering the fact that the state's National Guard, then engaged in a rebuilding effort, was actively recruiting men for the new Fiftieth Armored Division, Governor Alfred E. Driscoll advised Secretary of Defense James Forrestal that the New Jersey National Guard would be desegregated in compliance with the state's constitution and that men would be recruited into units regardless of race.

Driscoll then issued an order to his National Guard officers to disregard an army order stating that "mixed units are not authorized and Negroes cannot be enlisted in white units." Forrestal passed the buck down to U.S. Army secretary Kenneth C. Royall. Royall, in response to Driscoll, averred that although he considered regular army segregation to be "in the interest of national defense," he would make an exception for the New Jersey National Guard because the people of the state, in voting for their new constitution, had indicated that "no person shall...be segregated in the militia because of race, color." On February 12, 1948, the New Jersey

Black New Jersey guardsmen in a machine gun class after they became part of the 372nd United States Infantry during World War II. *National Guard Militia Museum of New Jersey/Sea Girt.*

adjutant general's office published General Order No. 4, noting that "no qualified person shall be denied any military rights, nor be discriminated against in exercise of any military rights, nor be segregated in the militia because of religious principles, race, color, ancestry or national origin."

New Jersey's actions put the state decisively ahead of the federal government in eliminating discrimination within the military. In 1945, then secretary of war Robert B. Patterson appointed a board of general officers headed by General Alvan C. Gillem to review the U.S. military's racial policies. The Gillem Board concluded that it was necessary to "eliminate…any special consideration based on race" within the armed forces. Throughout 1947 and 1948, President Harry Truman's advisors and black organizations and civil rights leaders pressed him to desegregate the military, and he essentially agreed to do so around the same time the New Jersey integration program was ordered. Truman did not, however, issue a military desegregation order until July 26, 1948. Foot dragging on the part of military officers, some of whom leaked to the press that the order did "not specifically forbid segregation in the army" delayed actual full implementation of the order below the battalion level until mandated by necessity during the Korean War, when General Matthew Ridgeway requested that he be allowed to integrate all units in his command in April 1951. There would be a hard road ahead to full civil rights, but New Jersey, thanks to its voters and Governor Driscoll, was at the forefront; the dream of equality New Jersey's black soldiers fought so hard for in 1865 finally began to be realized in 1948. It was a shame that the state's last Civil War veteran, African American First Sergeant George Ashby, Company H, Forty-fifth United States Colored Infantry, who died two years earlier, did not live to see it.

Sources for the story of the First Separate Battalion and the desegregation of the state's military include National Guard of the United States, Naval Militia, New Jersey Guard, State of New Jersey, 1940 *(State of New Jersey, 1940), as well as Colonel Len Luzky's "History, 1ˢᵗ Battalion, 372ⁿᵈ Infantry (Rifle) New Jersey National Guard," an unpublished lineage document, and William C. Lowe's "Sanspeur," an unpublished typescript manuscript, at the National Guard Militia Museum of New Jersey in Sea Girt.*

Swastikas Over Sussex

Flags emblazoned with swastikas, virulent verbal attacks against Jews and marching ranks of uniformed youths—such sights were not unique to late 1930s Germany. Hidden in the foothills of rural Andover Township, a group of Hitler enthusiasts dedicated to the "New Germany" that rose from the ashes of World War I formed their own hate-filled enclave in the dark years before World War II, a time when Germany's burgeoning military might and political posturing caused increasing concern on an increasingly nervous United States government.

The facility, known as Camp Nordland, became the site of fanatical rallies and venomous rhetoric promoting a "Gentile-ruled" America that excluded Jews from positions of importance and prosecuted all alleged communists for high treason. The camp was operated by the German-American Bund, an American version of the Nazi party whose members dressed in Nazi-style uniforms and gave the fascist salute. The leader of the Bund during the height of its power in the late 1930s was Fritz Kuhn, a swaggering Munich-born chemist and World War I German army veteran who demanded absolute obedience from his followers. Like Kuhn, most Bund members were recent, post–World War I, immigrants, not members of America's older, largely assimilated, German American community.

Although the Bund was headquartered in the Yorkville section of Manhattan, many of its lavish rallies and ceremonies were held at Camp Nordland. Situated on more than two hundred acres near the tiny town of Andover, the camp was a bizarre fantasy world of Nazism, dominated by a large yellow frame recreation hall with a prominent picture of Hitler displayed on an inside wall.

Nordland was a disturbing symbol of the Bund's growth under the charismatic Kuhn, who helped to expand the organization in the late 1930s, winning the support of an increasing number of German Americans sympathetic to the "New Germany." Kuhn built the Bund into the largest and best-financed Nazi-style group operating in America during Hitler's reign, boasting a membership of about twenty-five thousand at its peak in 1938.

Realizing the importance of grooming young, impressionable recruits to sustain his movement, Kuhn established youth groups in many Bund chapters, including in Newark. As part of his overall strategy to entice young people, he also organized an extensive network of more than twenty summer camps throughout the United States, where Bund officials disseminated inflammatory propaganda, drilled boys and girls in military formations and indoctrinated them in the philosophical tenets of Nazism.

Even before Camp Nordland's formal opening in July 1937, the Non-Sectarian Anti-Nazi League asked the federal government to investigate the recreational camp, contending that the facility was under Nazi control. Not so, countered a spokesman for Nordland, who said, with an apparent straight face, that the camp was entirely recreational and did not have any connection with the Nazi movement.

Yet according to Dr. Boris Nelson, secretary for the Anti-Nazi league, invitations bearing swastikas were issued to five thousand Nazi followers, inviting them to the camp's grand opening. "This is seventeenth such camp operating illegally on American territory under direct Nazi control," Nelson noted in an urgent telegram to Connecticut congressman William L. Citron. "Urge you to help close immediately all such Nazi military training grounds."

Despite the controversy, Camp Nordland opened as planned, with an estimated ten thousand sympathetic German Americans indulging in a

Fritz Kuhn believed in starting his Nazis early. These children were part of a ceremony that drew eighteen thousand people to Camp Nordland in 1937. *Joseph G. Bilby.*

day of celebration and beer drinking. A cynical reporter wryly noted that a survey of empty kegs after the festivities showed at least 75 percent of the beer consumed was American-brewed.

Political outrage increased in the weeks that followed, however, as evidenced when W.J. Carney, regional director of the Congress of Industrial Organizations union coalition in New Jersey, criticized the state's Governor Harold G. Hoffman for "laxity in the investigation of Nazi encampments at Camp Nordland and over New Jersey." In a telegram to the House of Representatives, Carney cabled: "It is significant that Governor Hoffman had no word of condemnation for un-American goose-stepping Nazis in their march of hate with the American flag flying below swastikas, in violation of rules of Congress for proper display of American flags," He demanded an "immediate investigation by Congress" of Kuhn's Sussex County playground.

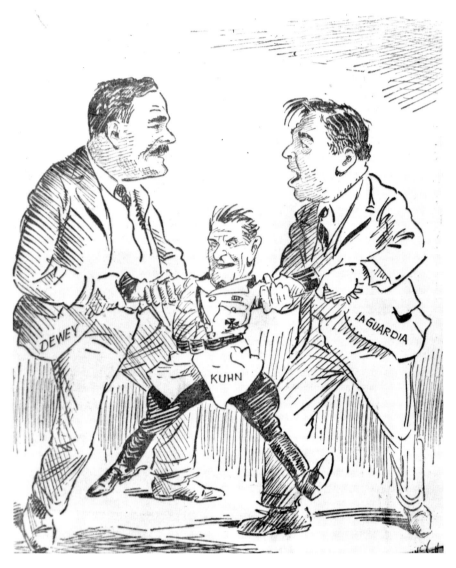

District Attorney Dewey, Fritz Kuhn and Mayor LaGuardia, from 1939. *Joseph G. Bilby*.

Despite the political furor, Camp Nordland continued to flourish and attract thousands of pro-German vacationers. Some four thousand Nazi sympathizers attended a May Day celebration there in 1938, where the new swastika flag of the German-American Bund was unveiled. Beer drinking and marching exercises by uniformed camp police and boys and

girls of the Youth Organization, coupled with oratorical attacks on Jews and Communists, were among the principal activities of the day.

Political arrogance and blatantly outrageous behavior soon became the hallmark of camp gatherings, as illustrated by the September 4, 1938 appearance of Kuhn. Speaking to a rapt crowd of two thousand Bund members and guests, the national Bund leader outlined a nine-point program that he hoped to implement in the upcoming year.

Noting that the Bund "can no longer be trifled with," Kuhn called for a "socially just, white, gentile-ruled United States" that prohibited Jews from holding "positions of importance" in government, national defense forces and educational institutions. He also called for a "thorough cleaning" of the Hollywood film industry and the "outlawing of the Communist party in the United States," among other demands.

Such overt rabblerousing not only raised the ire of many Americans but also, interestingly, sparked the consternation of numerous officials in Nazi Germany, who had come to consider the Bund a political liability. Anxious to maintain the goodwill of Americans as they continued to build a military force and make warlike moves in Europe, German leaders issued a formal statement disavowing the Bund. Such protestations did nothing to discourage zealous Bund members, however.

Despite the German government's attempts to disconnect itself from the American Bund, the shrillness of the Bund's rhetoric intensified, and so did public concern about its apparently growing influence. Throughout 1939, and especially following the signing of the Nazi-Soviet Non-Aggression Pact in August of that year, Germany's aggressive policies increasingly turned American public opinion actively against Hitler and exacerbated paranoia about possible covert Nazi activities in the United States. In August 1940, a terse *Time* magazine article noted that the German-American Bund boasted seventy-one units strategically located in industrial centers or near munitions works. "There are an additional 10,000 other Hitler-heiling Germans in the U.S. [and] 400,000 Germans who support Hitler but keep quiet about it," the article noted, in a bit of fear-mongering of its own.

In New Jersey, energetic opposition to the Bund had gained momentum in the late 1930s, spearheaded by organizations that included the Non-Sectarian

Anti-Nazi League of Newark, the German-American League for Culture, the Jewish-American War veterans, the American Legion and the "Minute Men," a group of hardened boxers and gangsters from Newark's Third Ward organized by well-known organized crime figure Abner "Longie" Zwillman. Zwillman unleashed his tough *schtarkers* on Bund meetings in Newark, and Nazi heads got cracked. In addition, many German American descendants of nineteenth-century immigrants increasingly regarded the Bund as an embarrassment, while officials and residents who lived near Nordland displayed their animosity in numerous ways, from revoking the camp's liquor license to hurling rocks at Bund members.

In 1941, New Jersey attorney general David Wilentz authorized a Sussex County sheriff's office raid on the Nordland property, shutting it down as a public meeting place under New Jersey's statute empowering authorities to close "every building or place where the law is habitually violated." In the raid, sheriff's officers and twelve deputized members of the local American Legion Post confiscated a quantity of Bund emblems, letters, maps and photographs of Hitler and ordered about one hundred picnickers and weekend residents of the camp's bungalow colony to pack up and leave.

That same year, Fritz Kuhn was charged with misappropriating $14,000 of Bund funds for his personal use, including supporting his mistress. While most Bund members thought that he was the victim of a frame-up, Kuhn was convicted of larceny and forgery and sent to Sing Sing prison. He was replaced as Bund leader by Gerhard Kunze of Union City, New Jersey. Kunze and several other key members of the organization were subsequently arrested and indicted by a Sussex County grand jury for violating a 1935 law prohibiting the promotion of hatred based on race or religion. Although the New Jersey Supreme Court overturned the decision, the Bund's days were numbered. When the United States instituted a military draft in September 1940, and Bund members were accused of counseling men on how to avoid service, many scattered. Kunze himself fled to Mexico. Following the American entry into World War II, the once grandiose but now deflated Fritz Kuhn was sent to an internment camp in Texas. In 1946, he was released and was deported to Germany, where he died in 1951.

In the aftermath of Pearl Harbor, Camp Nordland quickly became a fading symbol of Nazi efforts to manipulate German American sympathies. In 1944, the property was sold to a local real estate dealer. Today, the site is known as Hillside Park, and children play in the recreational fields where their counterparts from the past once marched in unison and chanted slogans of hate.

For further information on Bund activity in New Jersey, we recommend Warren Grover's Nazis in Newark *(Transaction Publishers, 2003).*

THROUGH THE HEDGEROWS
AND ON TO PARIS
Jerseymen Liberate the City of Lights

In 1893, the Essex Troop, an elite group of horsemen formed in Newark to participate in civil functions and parades, joined the New Jersey National Guard as Cavalry Company A. Under various designations, the troop has been an integral part of the Jersey Guard ever since. In 1913, the unit was expanded to become the First Cavalry Squadron of the New Jersey National Guard, with three troops, A and C in Newark and B in Red Bank. A Plainfield troop was subsequently added. In 1913, the Newark unit, members bedecked in their privately purchased English-pattern Brooks Brothers custom full-dress uniforms, went to Washington, D.C., as guard of honor for former New Jersey governor Woodrow Wilson's inauguration as president of the United States.

In 1916, the squadron was called to active duty to assist the regular army in defending the Mexican border against incursions by revolutionaries following Pancho Villa's raid on Columbus, New Mexico. The New Jersey Guardsmen were stationed at Douglas, Arizona, and never crossed into Mexico. After a brief return to New Jersey, the state's National Guard was called up again in 1917 for service in World War I. During the latter conflict, the squadron served in France not as cavalry but as military police for the Twenty-ninth Division.

After the war, New Jersey's cavalrymen were reorganized as the 102nd Cavalry Regiment. The 102nd, with troops then located in Newark, West

This plaque in Cranford honors the memory of Curtis Culin, 102nd Cavalry, New Jersey National Guard, who came up with the idea for the "Rhino Plow." *Cranford Historical Society.*

Orange and Westfield, was called to active duty on January 6, 1941, and sent to Fort Jackson, South Carolina, for a year of training. The Pearl Harbor attack in December, however, stretched the regiment's service from one year to five. Although the 102nd left New Jersey as a horse cavalry unit, it was officially designated a "Horse-Mechanized" regiment, with two squadrons containing both conventionally mounted and mechanized troops, in April 1942.

By September 1942, when the 102nd shipped out for England, it was completely mechanized, with its several squadrons equipped with "jeeps" produced by the Bantam Motor Car Company, armored cars, light tanks and self-propelled seventy-five-millimeter "assault guns." In December, the regiment's second squadron was transferred to North Africa, where it was eventually redesignated the 117th Cavalry Squadron and subsequently campaigned in Italy and France. The second squadron was replaced by the 38th Cavalry Squadron, composed primarily

Sergeant Culin in his Stuart M-5 tank. *Cranford Historical Society.*

of Iowans and Texans, and the regiment was redesignated the 102nd Cavalry Group, now composed of the 38th and 102nd Squadrons. The 102nd's commander, Colonel Donald McGowan, reassigned a number of his New Jersey officers and noncommissioned officers to the 38th. With this organization, the unit landed at Normandy on June 8, 1944, D-Day plus two.

One of the most significant displays of American wartime ingenuity can be traced to a New Jerseyan from the 102nd. As the Allies drove inland following D-Day, they became stalled in the *bocage*, a series of four- to six-foot-high earth berms topped with dense vegetation used to mark French farm boundaries in peacetime and now occupied as defensive positions by German troops. Attempting to cross the hedgerows, American tanks were pushed upward at a forty-five-degree angle, exposing them to enemy infantrymen armed with antitank weapons firing from cover. The offensive stalled.

Making Rhino Plows out of German beach obstructions. *U.S. Army Military History Institute.*

Sergeant Curtis Culin, a prewar National Guardsman from Cranford and a tank commander in the 102nd, suggested a solution to the problem. Culin proposed that "something like a snowplow" mounted on the front of a tank could carve a path through the hedgerows and that steel German beach obstructions would be the perfect material to craft such an apparatus. Sergeant Culin, Lieutenant Steve Litton of his squadron maintenance shop and Captain James DePew devised a forklike device to attach to the front of their tanks, and Warrant Officer Frank Reilly put his maintenance men to work on the job. The result, dubbed the "Rhino Plow," cut through both vegetation and dirt and, when it couldn't drive completely through a particularly stubborn obstacle, was able to poke holes that were subsequently filled with explosives to complete the job. The American high command quickly took notice, and General Omar Bradley pronounced the device "what we've been looking for." By July 24, every tank in the army was fitted with a Rhino Plow, and the Americans soon broke out of the *bocage* country.

The Rhino Plow on the front of a tank. *U.S. Army Military History Institute.*

Although the concept was his, Sergeant Culin was modest, insisting that credit for the plow "shouldn't go to any one person—because it took a whole American army, all clicking together, from the GIs up to the brass" to get the job done. His commander disagreed. In 1950, General Dwight D. Eisenhower, then retired from the army and president of Columbia University, met with Culin and a reporter in New York City. Ike looked across his desk at the Jersey boy behind the Rhino Plow and said, "Of course we had the kind of army in which a really good idea can quickly rise. But remember that someone has to have the idea. And that man was you!"

The army remembered Sergeant Culin as well, and Culin Hall at Fort Knox, Kentucky, was named for one of New Jersey's most historically important yet often-overlooked soldiers. Sergeant Culin survived the war, but not unscathed. A few months after the breakout, he dismounted from his Stuart M-5 tank and stepped on a land mine, losing a leg. Retired on disability, he died in New York City in 1965.

Jerseyman Led Yanks In Paris' Liberation

Roselle Captain Headed Cavalry Troop Which Sped Into French Capital

BY WARREN H. KENNET
Newark News Staff Correspondent

PARIS—A cavalry troop commanded by Capt. William J. Buenzle of 432 Mercer avenue, Roselle, was the first American unit to enter this city when it was liberated last Friday.

It came in at top speed, rolling neck and neck with the advance elements of the Second French Armored Division which had been designated to liberate Paris. The cavalrymen in armored cars and bantams roared up to the city limits and were faced with road blocks of felled trees and sandbags which had been set up by the Germans. Seeing the troops coming, French civilians tore the blocks away and the troops rolled on.

As the liberators neared the center of the city snipers hiding on the roofs and in the top floors of buildings fired at them and the troops were forced to sweep the buildings with machinegun fire.

Some Jersey Casualties

Meantime, I was with another unit of the cavalry which was entering the city from the south. We encountered considerable enemy action almost all the way. One platoon, from a troop commanded by Capt. Milton J. Hull of Maplewood, was pretty badly hit. The unit ran into a pocket of Germans on the outskirts of Paris and a number of men were either killed or injured.

I came into Paris in a Bantam with Lt. Donald W. MacAvoy of Plainfield, and was with Gen. de Gaulle when snipers made an attempt on his life after he had paraded from the Arc de Triomphe down Champs Elysees to Hotel de Ville.

We were moving our car to be

First in Paris

Capt. William J. Buenzle

A *Newark News* article by war correspondent Warren Kennet, describing Captain William J. Buenzle's mad dash into Paris. *National Guard Militia Museum of New Jersey/Sea Girt.*

In the wake of the Normandy breakout, hard fighting awaited the 102nd. Assigned as the reconnaissance unit for the 5th Army Corps, the 102nd was always out in front, screening American movements and providing intelligence on the enemy. First Sergeant James A. Kane of South Plainfield recalled that the unit was engaged in hit-and-run tactics for ninety-two straight days. By late August, as the Allies closed in on Paris, the spearhead of the effort was the two squadrons of the 102nd Group, each mustering about one thousand men. On August 24, as the fight for Paris turned into a "hell for leather scramble" on the roads leading to the city, the 102nd charged forward though rain, mist and German gunfire, recalled Captain William Buenzle of Roselle, who hoped that his troop of the 38th Squadron would be able "to race the French for the honor of being first into Paris." His men fought through the city's suburbs street by street, until they could see the Eiffel Tower in the distance, and then halted for the night. As Buenzle's soldiers approached Paris the following morning, French civilians rushed into the streets to disassemble German-built barricades. The Americans took sporadic sniper fire and returned it with machine guns, to the accolades of civilians who, mindless of the danger, poured out of their houses cheering.

Upon reaching the city limits, Captain Buenzle was ordered to "put the show on the road and get the hell into Paris." The captain urged his driver to speed up, and the cavalry column ran down the main road at forty miles an hour, heading for the city center. As they roared along, a unit from the Free French 2nd Armored Division entered the roadway, and the Americans raced their allies at "a dead heat the remainder of the way down to Notre Dame Cathedral." When Buenzle reported his position at 7:30 a.m. with the words, "I am at Notre Dame," the response from headquarters was, "How do you know?" Buenzle responded with, "Damn it, I am looking right up at Notre Dame!" Although Captain Charles H. Peterson from Cliffside Park, New Jersey, had actually quietly entered the city the night before with his Troop B of the 102nd, and his men provided a news photographer with an iconic image of an armored car riding under the Arc de Triomphe, Buenzle's dramatic entry race gained the Roselle captain and his men the credit and glory of being

the first Americans into Paris. In the end, it was of no matter, for New Jersey's 102nd could claim the honor either way.

Within a week, the 102nd had cleared Paris and was on its way back to war. There was hard fighting ahead, and some of the troopers who gained eternal glory bringing freedom to the City of Lights fell fighting at the Bulge or along the Siegfried line. The 102nd Cavalry Group ended the war in Czechoslovakia, and when it totaled up the grim score, it reported more than 150 men killed and many more wounded in action along the way. The 102nd's accomplishments fully upheld the proud reputation of the New Jersey soldiers who had gone before, as well as those who would follow—all Jersey Blues.

Harold J. Samsel's manuscript history of the 102nd Cavalry in World War II, newspaper clippings, oral history tapes, official correspondence and transcripts of radio communications from the 102nd Cavalry in World War II, used as sources for this section, are located in the archives of the National Guard Militia Museum of New Jersey in Sea Girt.

"Newark's Ernie Pyle"

*N*ewark *Evening News* reporter Warren H. Kennet, who preferred to be called "Harry," was born in England in 1901. The year after his birth, Kennet and his family moved to the United States and settled in New Jersey. He went to work as a reporter for the *News* in 1928 and eventually became the paper's equestrian correspondent. A sergeant in the 102nd Cavalry Regiment of the New Jersey National Guard, back in the days when cavalry meant horse soldiering, Kennet was a superb horseman, well known for his trick riding. As a journalist, he covered polo matches in the 102nd's armory on Roseville Avenue in Newark in the 1930s.

Even after his discharge from the National Guard, Kennet maintained a close association with the 102nd's core unit, the "Essex Troop," headquartered at the Roseville Avenue armory. The 102nd was called to active duty in January 1941 and sent to Fort Jackson, South Carolina, for a year of training. The Japanese attack on Pearl Harbor ensured that the Jersey troopers were in for the duration, however, and the 102nd left for England on September 24, 1942. With his military experience, it was a natural step for Kennet to become a war correspondent for the *Newark News*.

Regimental lore has it that Kennet, his application to become an official war correspondent still pending, stowed away aboard the unit's troop

Warren Kennet, war correspondent for the *Newark Evening News*, in 1945. *National Guard Militia Museum of New Jersey/Sea Girt.*

ship and arrived in England unofficially with the 102nd. While romantic, this story seems unlikely. In a December 1943 article posted from abroad, Kennet reported that he had been in England for two months, and the unit's World War II history notes that his first dispatch from the 102nd appeared in the *Newark Evening News* on October 26, 1943.

However he got there, Warren Kennet became a first-rate war correspondent who reported the conflict with a particular hometown twist and rode to the sound of the guns. One officer described him as "holding the simulated rank of Captain and the brass of a six star general." Kennet spent his time in England reporting on New Jerseyans from all over the state serving in bomber crews or preparing for the invasion of France, and he made side trips to North Africa and Italy as well. If you were a Jerseyman in uniform and you were serving in the European theater, the odds were that Warren Kennet would find you and write about you for the home folks.

2/20/44 **_Christmas Greetings from Battlefronts_**

Kennet's Christmas card to the staff of the *Newark Evening News*. *National Guard Militia Museum of New Jersey/Sea Girt.*

When Kennet arrived in England, all of the action was in the air, and so he sought out New Jersey airmen, putting together a "composite crew" of Jerseymen at a B-17 base that was home to planes bombing Germany. The crew included Lieutenant Robert A. Seaman of East Orange, a pilot who had buzzed Maplewood, Jersey City, Belmar and Bay Head with his bomber before going overseas in late 1943. Seaman survived the war and died in Charleston, South Carolina, in 2004. Another airman in the composite crew, Staff Sergeant Henry J. Annucci of Jersey City, had his plane shot down shortly after the article was published. Captured by the Germans, he was held as a prisoner of war from March 2, 1944, to May 12, 1945.

Kennet always had a nose for the odd New Jersey war story, and when one didn't present itself, he created it. In February 1944, he teamed U.S. Army Air Corps technical sergeant Donald Henderson, an aerial photographer and former all-state high school basketball player from Asbury Park, together with B-17 navigator Lieutenant Anthony Carbone of Atlantic Highlands, as the tallest and shortest men, respectively, on their English air base.

Kennet, always on the lookout for another New Jersey human interest story, became, on occasion, a participant in a story himself. In January 1944, he looked up a Newark woman's son, who had just married a British girl, and provided the new mother-in-law with photos of the happy couple. In May 1944, with the invasion of France imminent, Kennet organized, attended and wrote about an impromptu reunion of Newark's West Side High School alumni serving in England.

The intrepid reporter landed in Normandy on June 8, 1944, D-Day plus two, with his old friends from the 102nd. The first war correspondent on the beach, he dodged shot and shell and traveled with the unit across Europe to Paris, claiming, most likely correctly, to be the first American correspondent in the liberated city, where he had lunch with the staff of a French newspaper. As the war left Paris, so did Kennet, following the guns toward Germany. He rode at least part of the way across France in a captured German *kubelwagen* that the Jersey National Guardsmen personalized for him by painting "Newark Evening News" across its front bumper in the distinctive "Old English" script used in his newspaper's heading.

In December 1944, Kennet sent a Christmas card, signed simply "Harry," to the staff of the *News*, tracing his path as a combat correspondent from Normandy through France, Belgium and Holland to the German border. At the end of the month, he came back to New Jersey and then returned to Europe, where he accompanied New Jersey's prewar National Guard division, the Forty-fourth Infantry Division, in the final days of the war in Europe, ending it, with them, in Austria in 1945.

Although the men of the Forty-fourth were scheduled to return to the United States and then participate in the invasion of Japan, and Kennet was prepared to go with them, his (and everyone else's) war ended with the Japanese surrender. As an official United States war correspondent, he was awarded the European Campaign Ribbon with six battle stars, an Arrowhead signifying participation in the Normandy invasion, a certificate of merit from the secretary of war and the French Legion of Honor.

In the postwar years, Kennet continued as a military correspondent for the *Newark Evening News*, visiting Korea and Cold War venues around the world, receiving awards for his reporting. In 1949, he returned to France to recapture his wartime experience, visiting the once bombed-

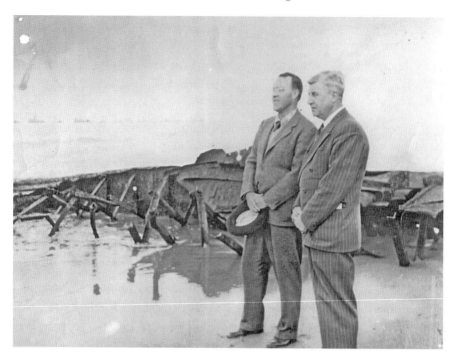

Warren Kennet and friend at Normandy, June 6, 1954. *National Guard Militia Museum of New Jersey/Sea Girt.*

out city hall in Isigny, where Major Arthur C. Person of the 102nd had his command post in the days after the invasion, as well as places where he had seen men die and had narrow escapes himself. After walking along the now strikingly peaceful Omaha Beach, Kennet followed a trail up a hill that he remembered as strewn with broken equipment and bodies. And then he stopped and noted with emotion, to an imaginary soldier-reader that was really him, that "the tears would come to your eyes as the horrible things you saw came back to you." And they no doubt did.

Kennet returned to New Jersey and then came back to Normandy one last time in 1954 as one of forty-five American war correspondents flown to France for the tenth anniversary of D-Day. There were still, a decade later, a few rusted landing craft scattered here and there. He walked along the shoreline, and then, as in 1949, ultimately sought out, high atop the beach, the Saint Laurent Sur Mer Cemetery, where he checked the names of the dead and visited those he knew.

Back in Newark, Kennet would hold forth at the 102nd's unofficial clubhouse, John P. Teevan's Clipper Ship tavern next door to the armory. Frank L. Carlone—a guy from the neighborhood who, as a boy, had shined shoes all day long for the Essex troopers when they went off to war in 1941 and was now an officer in the National Guard himself—used to visit Kennet at home. And one day, Frank said, "You know, Warren, you're Newark's Ernie Pyle." Kennet modestly protested, but Carlone had hit on something good and true.

Warren H. Kennet remained a reporter with the *Newark Evening News* until that grand old publication regrettably closed its doors in 1972, and he died in Newark a decade later. A courageous war correspondent who spent months under fire with the 102nd, Kennet was remembered by those who knew him as a "good guy" and a "considerate, warm and patient" man. Kennet was a journalist of distinction who put his life on the line to keep New Jerseyans informed of their men at war. In remembering that war, we should all cherish his memory as well.

Warren Kennet's scrapbook and other memorabilia, as well as Harold J. Samsel's manuscript history of the 102nd Cavalry in World War II, are in the collections of the National Guard Militia Museum of New Jersey (NGMMNJ), which has a standing exhibit on his work. That material, a manuscript history of the 102nd in the NGMMNJ library and an interview with Colonel (retired) Frank L. Carlone were the sources of this story.

ROSEVILLE'S MYSTERY MAN

The Enigmatic Moe Berg

Hey kid, c'mere. See that guy. The guy with all them newspapers going into Gruning's? That's Moe Berg. He's famous—a big-league ballplayer. And he did some kinda big stuff during the war, I hear." Such was how a young Joe Bilby, back in the early 1950s, was introduced to the story of the most famous athlete ever to emerge from the Roseville section of Newark. For a long time, he forgot it. But as a story both fascinating and strange, the tale of Moe Berg has few parallels in New Jersey history.

Morris "Moe" Berg was actually born in New York City in 1902. When Moe was four, his father, Bernard Berg, a Russian Jewish immigrant, moved the family to Newark, where he bought a pharmacy in the Roseville section of the city. Moe, his sports ability in evidence early on, first played organized baseball for the Roseville Methodist Church team under the pseudonym "Runt Wolf." He went on to play for Barringer High School and was generally accounted the best ballplayer Newark had ever produced—and he was brilliant as well. Moe went on to Princeton, where he played baseball and majored in modern languages. According to one story, Berg, a shortstop, soon displayed the eccentricity that would become his hallmark, communicating with his second baseman in Latin.

Following his 1923 graduation from Princeton, Moe Berg embarked on a somewhat erratic career in professional baseball. He never played

Moe Berg in a Boston Red Sox uniform. *Joseph G. Bilby.*

in more than one hundred games in a single season and, in many years, participated in less than fifty. Beginning with the Brooklyn Dodgers as a utility infielder, Berg subsequently played for the Chicago White Sox, Cleveland Indians, Washington Senators and, finally, the Boston Red Sox, the team with which he is most often identified. Less than an all-star (it was said the quote "good field no hit" was invented to describe his play), he posted an anemic .243 batting average over a fifteen-year career. After moving from infielder to catcher, however, Berg earned a reputation for working well with pitchers and was reputed to have a "rifle arm" that compensated for his weak hitting. He continued his academic career at the same time, earning a law degree from Columbia University and taking time off for a semester at the Sorbonne in Paris. Perhaps more than any other baseball player of his generation, the urbane, sophisticated and gregarious Berg made friends in high places, including Nelson Rockefeller.

Baseball was introduced to Japan by an American missionary in 1872. In 1913, 1922 and 1931, groups of American major leaguers toured the

country, playing exhibition games against Japanese university teams. In 1932, National League player Herb Hunter assembled a traveling teaching team to instruct the Japanese in the fine points of the game and asked Berg to conduct catcher training. Moe, his interest in exotic culture piqued, enthusiastically accepted. On the cruise over, he taught himself passable Japanese from a book and, upon arrival, immersed himself in the local culture, eating sushi with chopsticks, wearing a kimono and sleeping on a tatami mat. When the other players returned home, Moe toured Japan with a Japanese teacher he had befriended, soaking up language and culture like a sponge. When he finally left, he took the long way home, rambling through China and southeast Asia.

By 1934, tensions were rising between the United States and imperial Japan, but Herb Hunter organized a Japanese exhibition baseball tour featuring the aging Babe Ruth and other all-stars, including Jimmie Foxx and Lou Gehrig. When catcher Rick Ferrell decided not to go, Hunter invited Berg, who jumped at the opportunity to return to the Orient. On this trip, Moe carried a sixteen-millimeter camera, apparently supplied by the newsreel company MovietownNews. While the other players got drunk at the ship's bar, Berg studied his Japanese. Even in the spy-obsessed Japan of the 1930s, he was able to film local sites without attracting undue attention. On one occasion, he visited a hospital and, wearing a kimono that concealed his camera, made his way up to the building's bell tower to record a panoramic view of Tokyo, including shipyards and military bases. On the way home, he visited Korea, took the trans-Siberian railroad across the Soviet Union, got caught filming in Moscow and had his camera confiscated by the secret police and eventually ended up back at the family home in Roseville, with his Japanese footage intact.

Moe Berg resigned from the Red Sox, for whom he had been a coach for the last years of his baseball career, in January 1942, one month after the United States entered World War II, and his friend Nelson Rockefeller got him a job traveling for the state department in Latin America. Berg brought his amateur films of Tokyo to American intelligence officials, however, and by 1943, he was working for the Office of Strategic Services (OSS), the forerunner of the CIA. Although the detailed maps and photos of Tokyo made by an American naval attaché before the war

were no doubt more valuable in the long run in determining bombing targets in the city, Berg's films apparently generated interest in him and his not inconsiderable abilities.

Ironically, all of Berg's OSS work was in Europe. Although he may not have been the best agent fielded (one story has him accidentally dropping his gun in another passenger's lap on a commercial airplane flight), his proven linguistic talents, intelligence and ability to move easily in foreign social circles were all real advantages in that line of work. In December 1944, after spending time in Italy, Berg was dispatched on an undercover mission to neutral Switzerland, where he attended a seminar and then a dinner held by a pro-American Swiss scientist for German nuclear scientist Werner Heisenberg. Moe, fluent in German, gave himself a crash course in nuclear physics and was tasked with assessing Heisenberg's presentation for information on whether the Nazis were close to producing an atomic bomb. He correctly concluded that they were nowhere near that goal, although there is actually reason to believe that Heisenberg was not a principal in the effort anyway. Whether or not Berg, as he later claimed, actually had orders to kidnap or assassinate the German if he concluded otherwise is unclear. On another occasion, at the end of the war in Czechoslovakia, Berg reportedly saved himself and several other undercover officers from being held by the Russians by flashing a letterhead with a red star on it, which they took as a Communist pass but was actually correspondence from Texaco Petroleum.

Following the end of the war, Berg conducted a few missions for the then new CIA but was never picked up as a permanent agent. He moved back to Roseville, living first with his brother, Dr. Samuel Berg, on Roseville Avenue and then a few blocks away with his sister, Ethel Berg, reputed to be the best kindergarten teacher in the history of Newark and a notable local eccentric in her own right. In lieu of going to work, Moe would walk to Gruning's ice cream store and luncheonette on Orange Street every morning, a pile of papers in different languages under his arm, and then ostentatiously read them at the counter while nursing a cup of coffee. In 1972, Berg became ill and ended up in Clara Maass Hospital in Bellville, where he died of an abdominal aortic aneurism on May 29 after uttering the last words, "How are the Mets doing today?" Ethel had

A view of Orange Street, looking north from North Seventh Street toward Roseville Avenue, circa 1959. Gruning's ice cream shop, where Berg drank his morning coffee while reading newspapers in several languages, is visible just before the bank building. The picture was taken by Moe Berg's brother, Dr. Samuel Berg. *Berg Collection/Newark Public Library.*

Moe cremated and buried, but two years later, without telling her brother Sam, she dug his urn up and took him to Israel, never revealing what she did with him there. And so Moe Berg's ultimate end remains as much of a mystery as the man himself.

There are several biographies of Moe Berg, but the one we like the best is Nicholas Dawidoff's The Catcher Was a Spy: The Mysterious Life of Moe Berg *(Pantheon, 1994).*

Terror Train in Woodbridge

It was a crowded commute home aboard Pennsylvania Railroad train Number 733, known as the "Broker" due to the preponderance of Wall Street workers onboard. The Broker's steam engine pulled out of Jersey City each day and sped across the urban and suburban landscape of central New Jersey at about sixty miles per hour, passing through Woodbridge on its way to the Jersey Shore and its terminus at Bay Head. The train's eleven passenger cars were especially cramped that winter evening, with many commuters forced to stand, due to a wildcat strike by workers from the competing Jersey Central Railroad.

In the drizzly dusk of February 6, 1951, comptroller Frank Muller was chatting with a fellow Ocean Grove resident, Douglas Smith, when he sensed that the train seemed to be traveling at an unusually high rate of speed. "I wonder what this guy is thinking about," he said to his traveling companion, referring to the engineer.

Suddenly, the train seemed to veer off into a different direction. "I knew we weren't going to make the curve," Muller later recalled. Instead, the commuter train careened from the rails and plunged off a temporary trestle bridge in Woodbridge. The Broker hurtled down a forty-foot embankment, killing eighty-four passengers and one crew member, the fireman, in one of the most horrific transportation accidents in United States history and certainly the worst in New Jersey history. The sound of "screeching brakes,

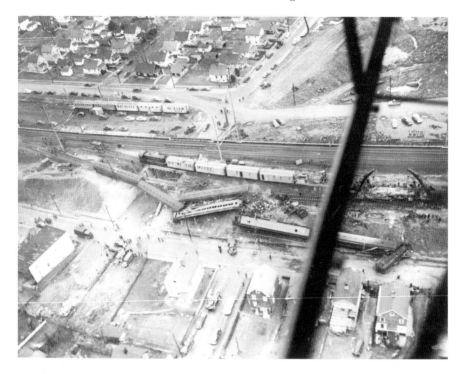

An aerial view of the aftermath of the Broker wreck, with the cars spilling down toward Fulton Street in Woodbridge. *Frank LaPenta.*

ripping steel and noise like an atom bomb shattered the evening air" as the express train veered off the bridge at Fulton Street, according to a local news report. One Fulton Street resident who was eating supper at the time said that it "sounded like a bomb had fallen some distance away."

The immediate aftermath was unspeakable. The engine lay on its right side atop the embankment, while the tender jackknifed and ended up in Fulton Street. The passenger cars were scattered and twisted, with one on the slope to Fulton Street. Another car stood upright on the muddy embankment. The fourth car had slid alongside the third car, ripping it open and leading to some confusion as to which of them was the scene of the most violent deaths, as both ended up alongside each other. Bodies were strewn inside and out of the wrecked cars.

Muller remembered an eerie quiet after the crash. "There was no emotion, no panic," he said, as he began searching for his traveling companion, Smith, whom he found alive some fifteen feet away. Smith

had been thrown from his seat and was lying against a car door. "We were lucky," Muller later told a reporter. "Some of the others in our car ended up in the coal car. Others were thrown clear of the first car."

Within minutes, the scene was one of unimaginable chaos. Woodbridge police received the first call at about 5:45 p.m. and dispatched every available piece of emergency equipment to the scene. They were soon assisted by fire and first-aid departments from towns throughout Monmouth and Middlesex Counties. National Guard troops were called out for crowd control as the morbidly curious descended on the site from miles around.

Emergency personnel were confronted with a scene of overwhelming horror. Hundreds of passengers were trapped inside twisted steel cars, while the engine rested on its side, belching smoke and scalding steam. The injured were carried to nearby homes, and in many cases, the dead

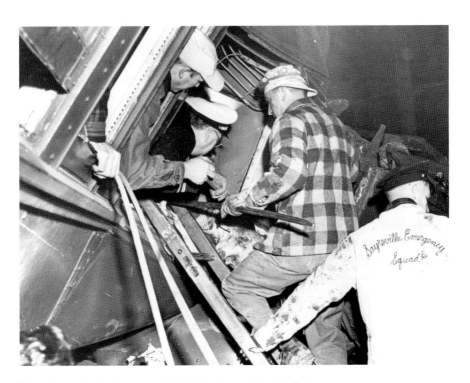

Removing a victim from one of the Broker's cars. *Frank LaPenta.*

were laid out in stretchers in the street. Priests worked their way among the rescuers, administering last rites to the dead and dying.

Initially, confusion had reigned, but emergency "disaster preparedness" plans quickly fell into place, bringing order out of chaos. Narrow, dimly lit Fulton Street was soon jammed with rescue workers, newsmen and photographers. Ambulances jumped curbs to reach those in need, while emergency personnel worked beneath the cars, which hung at precarious angles. One car almost rolled through the soft mud of the embankment until workers secured it with cables.

The next day, the *Asbury Park Press*'s front-page coverage included a grim list simply labeled "The Dead." It was a who's who of Shore-area executives from Point Pleasant, Long Branch, Spring Lake, Ocean Grove and numerous other communities. At the final count, eighty-five people were killed and five hundred injured.

In the aftermath, the engineer, Joseph H. Fitzsimmons, who had survived the crash by crawling out from under the engine before losing consciousness, became the focal point of the official investigation. When questioned by authorities, Fitzsimmons said that the crash was sudden. He said that he slowed the train as he approached the trestle bridge. "I always slowed down there, that's the only way you can travel that road," he told investigators. Fitzsimmons later changed his story somewhat, admitting that he might have been going faster than he had previously claimed and said that he was looking for the yellow lights that signaled a reduced speed area.

The evidence, however, seemed to prove otherwise, indicating that Fitzsimmons was traveling about fifty miles per hour at the time of the accident, despite the fact that crews had been issued a "General Order" by the railroad to slow to twenty-five miles per hour in Woodbridge several days earlier, since the trestle bridge was only a temporary structure put in place while a new rail bridge was being built in conjunction with construction of the New Jersey Turnpike.

Additional testimony revealed that the train's head conductor, John Bishop, had reminded Fitzsimmons about the new speed limit in Woodbridge shortly before they left Jersey City, had sensed that the train was moving too quickly and had attempted to pull the emergency brake. He couldn't reach it in time due to passengers blocking the aisle.

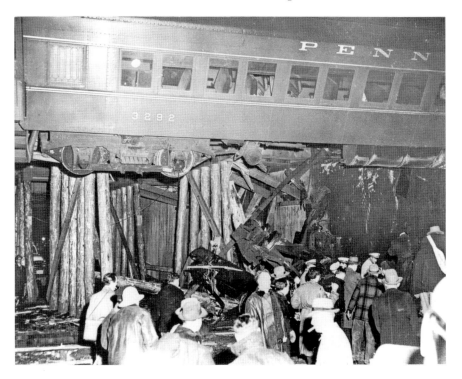

Crowds gathered around the wreck in short order. *Frank LaPenta.*

Dozens of families, outraged by the needless tragedy, filed lawsuits against the Pennsylvania Railroad Company, resulting in some $75 million in settlements. In addition, the railroad installed an estimated $12 million in warning lights, which had not existed before the accident. Middlesex County prosecutor Alex Eber filed eighty-four counts of manslaughter against the railroad, contending that the absence of yellow flags or lights in Woodbridge was the cause of the accident. The railroad contended that the "General Order" to slow down in Woodbridge eliminated the need for such warning signals. Eber eventually dropped the case to avoid spending the $2.1 million the county would need to prosecute it to conclusion.

The devastating crash left an emotional scar on families scattered throughout the Shore area, traumatized by the senseless loss of loved ones due to apparent carelessness and mismanagement. A year after the tragedy, a group of survivors asked that the train halt at the Fulton Street

site on the anniversary of the disaster. The railroad refused. The only acknowledgement was provided by Fred Houck, leader of the group, who dropped a floral bouquet from the moving train.

To date, there has not been a book on the wreck of the Broker, although one is in preparation. Information for this account was obtained from the Asbury Park Press *and* Home News Tribune *newspaper coverage of the event, as well as at the Woodbridge Township website: http://woodbridgetownshipnj.tripod.com/ woodbridgetraincrash. Thanks are also due to Gordon Bond for his input on this story.*

About the Authors

JOSEPH G. BILBY was born in Newark, New Jersey, received his BA and MA degrees in history from Seton Hall University, South Orange, New Jersey, served as a lieutenant in the First Infantry Division in Vietnam in 1966–67 and is the author or editor of more than three hundred articles and fourteen other books on New Jersey and military history, including his latest work, *Freedom to All: New Jersey's African-American Civil War Soldiers*. Retired from the New Jersey Department of Labor as supervising investigator, he is a trustee of the New Jersey Civil War Heritage Association, publications editor for its 150th Anniversary Committee and assistant curator of the National Guard Militia Museum of New Jersey. *New Jersey Goes to War*, which he edited for the Sesquicentennial Committee, won the New Jersey Studies Academic Alliance award as best New Jersey reference book published in 2010. He is also the 2011 recipient of the Jane G. Clayton Award for "exceptional contributions to an awareness, understanding, and/or preservation of the history of Monmouth County, New Jersey."

JAMES M. MADDEN was born in Jersey City, New Jersey, received his BA in marketing from Saint Peter's College in Jersey City and has contributed articles to many Civil War publications and projects, including the New Jersey Civil War Sesquicentennial publications *New Jersey Goes to War* and

New Jersey's Civil War Odyssey. A political consultant, he is also a trustee of the New Jersey Civil War Heritage Association and its 150th Anniversary Committee, a trustee of the Historic Jersey City and Harsimus Cemetery, a member of the Association of Professional Genealogists (APGEN) and a trustee of the Jerramiah T. Healy Charitable Foundation for a Better Jersey City.

HARRY ZIEGLER was born in Neptune, New Jersey and received his BA in English from Monmouth University, West Long Branch, New Jersey, and his MEd from Georgian Court University, Lakewood, New Jersey. He worked for many years at the Asbury Park Press, New Jersey's second-largest newspaper, rising from reporter to bureau chief, editor and managing editor of the paper. He is currently associate principal of Bishop George Ahr High School, Edison, New Jersey, and is coauthor of *Asbury Park: A Brief History*.

Visit us at
www.historypress.net